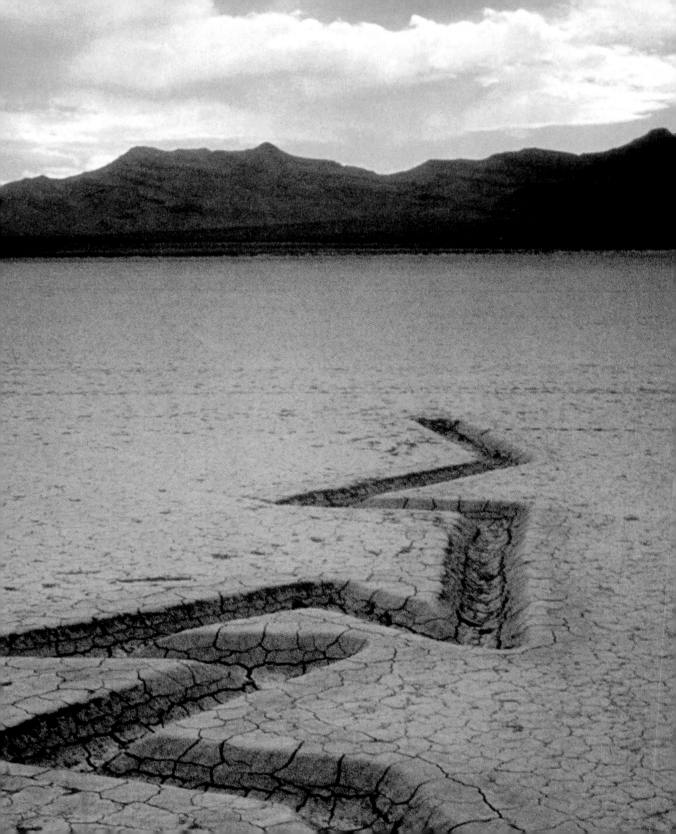

Land Art

Michael Lailach
Uta Grosenick (Ed.)

TASCHEN

HONG KONG KÖLN LONDON LOS ANGELES MADRID PARIS TOKYO

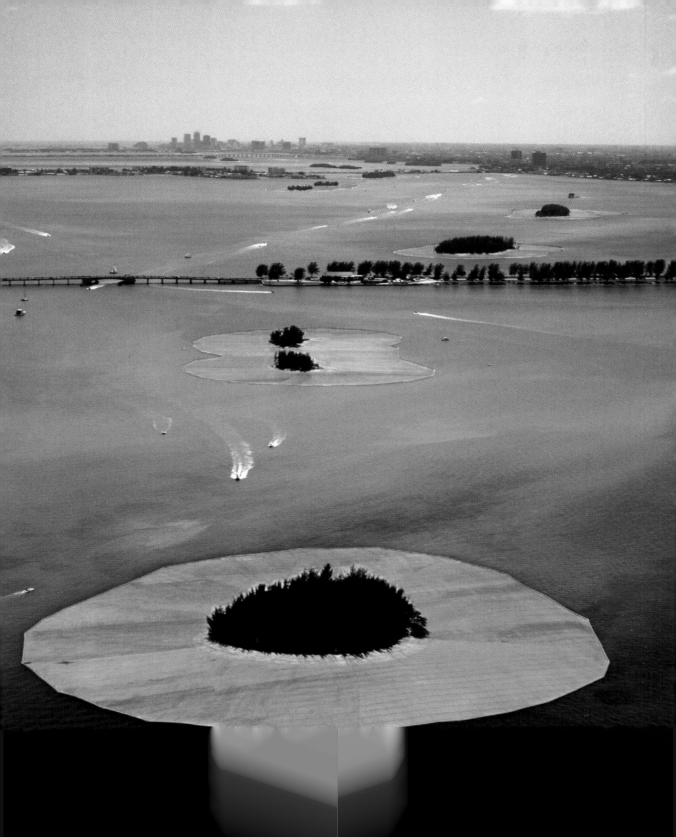

contents

beyond
the white cube

One can still sense something of the irritation and reticence that art critic John Anthony Thwaites must have felt upon viewing the made-for-television film *Land Art* in 1969: "They go out into the deserts and onto the oceans. There, where it is loneliest, they engage in their games with the elements. Generally, only a camera observes their activities. Their transient works are quickly scattered by the wind, washed over by water. As well, where these works enjoy the protection of museums – and are continually renewed and maintained – they are homages to the past. A new myth of nature has infected the fine arts."

The film is indebted above all to the concept by and initiative of Gerry Schum, who served as its director, producer and cameraman. Schum was searching for a new venue for art, and hoped television would hold previously unexploited potential for artistic work. Logically, he billed his film as a "television exhibition".

He showed works by eight American and European artists: Marinus Boezem, Jan Dibbets, Barry Flanagan, Michael Heizer, Richard Long, Walter De Maria, Dennis Oppenheim and Robert Smithson. From the start, the artists had conceived these works for presentation on a television screen, only to be seen while the program was on air. This could not possibly have been otherwise, since they created the works in remote locations that were (at the time) unusual for artistic actions: a moor, a coast, a stone quarry, and a desert. Some of the artists had never worked in such locations before, and some of them would never do so again. In every respect, the project was experimental and unique.

One of the contributed films, *12 Hours Tide Object With Correction Of Perspective*, was produced by the Dutch artist Jan Dibbets. Dibbets had a heavy front-end loader drive up and down a beach on the coast of Holland. The marks left by its bucket formed a trapezoidal pattern in the sand. The images seen on television, however, create the impression that the front-end loader is travelling along the screen's edges, and viewers believe they are seeing a square pattern on the television screen's convex surface. This – illusory – "correction of perspective" evoked on the screen is intentional. The artist selected image framing and camera angle in such a way as to translate the trapezoid into a square upon playback. "The whole thing," explained Dibbets, "is specially constructed for T.V. So on the moment people are looking at this project on T.V. they have (during that time) an originally art-work by Dibbets in their room. When it is finished the work of art doesn't exist any longer. T.V. as an art-object."

1961 — The Russian Yuri Gagarin becomes the first person in space

1961 — Construction of the Berlin Wall comes to symbolize the Cold War

"The whole thing is specially con-structed for T.V. so on the moment people are looking at this project on T.V. they have (during that time) an originally art-work by Dibbets in their room."

Jan Dibbets

1. GERRY SCHUM

Land Art
1969, poster, 59.2 x 42.1 cm
Sammlung Marzona, Kunstbibliothek,
Staatliche Museen zu Berlin

2. JAN DIBBETS

12 Hours Tide Object with Correction of Perspective
1969, film stills from *Land Art*
Sammlung Marzona, Kunstbibliothek,
Staatliche Museen zu Berlin

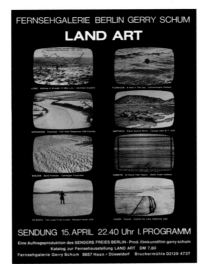

1

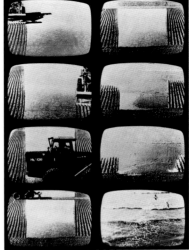

2

The film was broadcast only once, on April 15, 1969 at 10:40 p.m., on German television's channel 1 (ARD). Its title *Land Art*, however, was to become a brand label for artistic work in the land-scape. The name arose from an abbreviation of "landscape art". Thereby Schum's choice was good, and art critics happily took up the term. It had not yet been fully defined, and its openness encouraged the most varied interpretations: "Spiele mit den Elementen" (playing with the elements), "Flucht ins Freie" (escape outdoors), "Spuren-graben" (trace excavation), "Suche nach der blauen Blume" (search for the blue flower), "artifizielle Welt-Veränderung" (artificial world-change). Despite widely varying appraisals, art critics agreed that the aesthetic concept of landscape had taken a new and momen-tous turn.

sculpture in the expanded field

Since antiquity, landscape has been a theme of literature and art: In ancient pastoral poetry it was the idyllic setting of rural life. Since the 14th century, the landscape's forms and colours have been recorded in paintings, drawings and prints. In 18th century philosophical writings, a view of incomprehensibly distant mountains served to describe the feeling of the sublime. In the 20th century, all landscape images that contradict our customary viewing habits have become emblematic of the culture-critical programmes of Surrealism, Expres-sionism and Futurism: as a manifestation of another way of seeing, and of the "spiritual in art" (a concept coined by the Russian abstract painter Wassily Kandinsky). Yet the diverse and contradictory descrip-tions and landscape images are indebted not only to individual artistic perspectives, but also to changing societal contexts. Cartographic sur-veys, military conflicts, new trade and travel routes, and technological innovations in agriculture have lastingly changed the face of land-scape. A symbolic claim to possession and power has always marked landscape's portrayal.

Landscape as an art theme took on an unexpected, anti-symbolic dimension around 1968, when a small group of American and European artists developed designs, concepts and projects employing new and unconventional techniques and materials, and different loca-tions and dimensions. No longer just described in texts or depicted in paintings, landscape was also used as an artistic material. The artists produced their works directly on location, which created new and unique problems. Were these works sculptures, architecture or land-

1962 — The Cuban missile crisis underlines the danger of a nuclear confrontation between the USA and Soviet Union
1962 — The first TV satellite Telstar goes into orbit

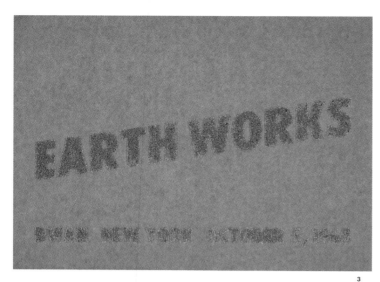

3.
Earth Works
1968, Dwan Gallery invitation card,
New York
Sammlung Marzona, Kunstbibliothek,
Staatliche Museen zu Berlin

4.
Earth Works
1968, exhibition in the Dwan Gallery,
New York

3

scape design? When the American art critic Rosalind Krauss coined the expression "sculpture in the expanded field", she had exactly this irritating transgression of artistic categories in mind. Beyond the problem of logical categorization, a critical question emerged: How could one show this art in gallery and museum spaces? The works in the landscape were not transportable and often impermanent. One could also label them "heterotopias", to use a term of Michel Foucault's. This French philosopher used the term to refer to "places that do exist and that are formed in the very founding of society – which are something like counter-sites". Heterotopias are "a kind of effectively enacted utopia in which the real sites, all the other real sites that can be found within the culture, are simultaneously represented, contested, and inverted. Places of this kind are outside of all places, even though it may be possible to indicate their location in reality".

The idea for the television exhibition *Land Art* was an initial reaction to these contemporary problems of presentation. In his introduction, Gerry Schum emphasised not just the communicative aspect of "directly confronting as wide an audience as possible with current trends in the world of international art", but also expressed vehement criticism of the business of art. He considered galleries and museums too limited and too involved in their own economic interests, and he

considered television the fitting solution in the search for a new site for art. This hope would turn out to be illusory.

Together with Ursula Wevers, his partner in life and in work, Gerry Schum prepared the broadcast very carefully. He had a poster printed, invitations sent, and a catalogue published. Filming took place with the artists in eight locations in England, Holland, France, Canada and the USA. The opinions of various experts were sought, and long negotiations were held with the television station. The project was ill starred, however. There were problems with organisation and financing, and the television station remained leery of the new form of presentation, which corresponded neither to narrated television documentaries, nor to avant-garde artistic films. Although Schum was later able to produce a second television exhibition entitled *Identifications*, he subsequently had to abandon his project for good.

The title *Land Art* is what best remained in memory from the two television exhibitions, for in European usage the term came to denote artistic works in and with the landscape. In American usage, on the other hand, the expression Earthworks became common. This was not just coincidental, for in a sensational exhibition in October 1968 the Dwan Gallery in New York showed new works, the only common feature of which was their use of earth as a material.

1962 — The environmental activist Rachel Carson publishes her celebrated book "Silent Spring" 1963 — Murder of John F. Kennedy
1963 — "I have a Dream" speech by Martin Luther King Jr. during the "March on Washington"

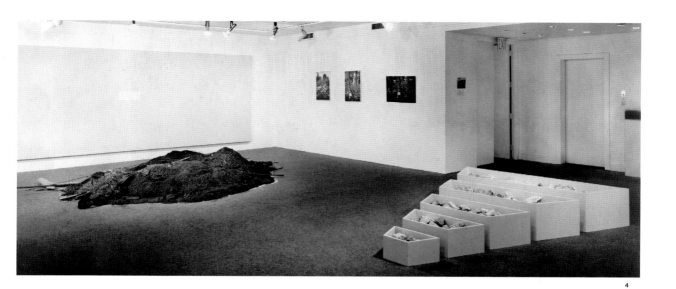

4

Earth works

Ten artists took part in the *Earth Works* exhibition, some of whom were successful then and remained so, whereas others, such as Stephen Kaltenbach, are (unjustly) barely remembered today.

The words "Earth Works" were legible in letters of fine-grained sand on the exhibition's invitation card, designed by gallerist Virginia Dwan. In fact, most of the works presented consisted of earth and stone. Photographs, however, were also shown: by Carl Andre who had placed a series of heavy wooden beams throughout a wooded area, and by Sol LeWitt, who had buried an aluminium cube in a Dutch collector's garden. Michael Heizer exhibited a slide of his work *Dissipate # 2* in a large backlit slide viewer, and Robert Smithson used photographs to show the locations where he had collected the stone for his mixed media work *Nonsite, Franklin, New Jersey*.

The presented works included surprisingly diverse media and materials, even though their common feature had been stipulated as earth. Dennis Oppenheim exhibited the model *Mt. Cotopaxi Transplant*. The model's surface, layered with cocoa, represented a cornfield at the geographical centre of the USA (Smith Center, Kansas),

onto which Oppenheim wanted to transfer an extremely magnified version of the contour lines with which the volcano Cotopaxi in Ecuador had been cartographically documented. Stephen Kaltenbach presented a blueprint for his project *Earth Mound for a Kidney-Shaped Swimming Pool*, and Claes Oldenburg exhibited his *Worm Earth Piece*, a Plexiglas cube filled with earth and worms. Robert Morris' contribution *Earthwork* was a pure and simple provocation, since it looked like a construction site rubble heap: Morris dumped earth, peat, hardened grease, stones, pipes, wire and felt on the gallery's grey carpeting.

As is so often the case with group exhibitions, the overall impression made by the works was not uniform, and the artistic interests were highly diverse. The publications by Robert Morris and Robert Smithson are an example of this. In the same year as the *Earth Works* exhibition, Morris also published his essay *Antiform*. In this text he postulated a new, process-oriented form of art, which would take the qualities of the materials into account. Morris believed all formal structuring of material to be an approach extrinsic to physical things: "An order, any order, is operating beyond the physical things … Considerations of ordering are necessarily casual and imprecise and unemphasized. Random piling, loose stacking, hanging, give passing form to material

1963 — Kodak introduces their "Instamatic" cameras on the market
1963 — First Marcel Duchamp retrospective shown in the Pasadena Art Museum in the USA 1964 — Beginning of the Vietnam War

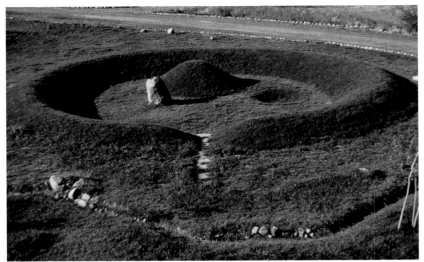

5. HERBERT BAYER

<u>Earth Mound</u>
1955, Aspen, Colorado; grass, earth,
Ø ca. 12 m

6. CLAES OLDENBURG

<u>Placid Civic Monument</u>
1967, Central Park, New York; excavation,
ca. 1.80 x 0.90 x 0.90 m

7. CARL ANDRE

<u>Lever</u>
1966, installation in the Jewish Museum,
New York; 137 bricks, length ca. 8.80 m

5

… Disengagement with preconceived enduring forms and orders for things is a positive assertion."

Robert Smithson, however, was pursuing completely different considerations. In his essay of the same year *A Sedimentation of the Mind: Earth Projects* he introduced the expression "Nonsite" for his containers of collected materials with maps, photographs and texts. Smithson intended this paradoxical phrase to reflect the irresolvable tension between exterior and interior space in such "indoor earth-works", while simultaneously admitting the compromise that he would make in productively reversing the principle: "I have developed the Non-Site, which in a physical way contains the disruption of the site. The container is in a sense a fragment itself, something that could be called a three-dimensional map."

The exhibition *Earth Works* provoked an unusual amount of re-action, since the challenge to all art-related conventions was obvious. Here the gallery was only a place to exhibit documentation, plans and models of works located elsewhere, or a place where one was con-fronted with a raw material that one not only did not expect, but did not want to see at all.

For this reason the artist and critic Sidney Tillim complained about this art's theatrical aspect, for he believed that passing off the reverse of picturesque upon viewers as a new longing for nature was deceitful of the artists. "But the picturesque," said Tillim, "was more than just a theory of landscape in nature and art. It was a crucial episode in the history of taste. Less than sublime, yet seeking a surro-gate for the ideal, it signalled, by virtue of its resultant sentimentality, the end of the ideals of high art." Other critics such as Grace Glueck praised the artistic idea of wanting to alter the surface of the earth, as though one could discover progressive ecological intent here: "A BACK-TO-THE-LANDSCAPE show is burgeoning at – of all places! – the Dwan Gallery … Called *Earth Works*, the show boasts projects by nine artists who reveal their geophilia in photos, models and actual chunks of ground."

In her *New York Times* review, Glueck hit the mark when she described the exhibition as a sensational show with (overly) ambitious projects. The photographs, films, models, piles of earth, and steel-containers of stones left her with the impression that it was only con-cerned with one thing: "The medium (and message) is Mother Earth herself – furrowed and burrowed, heaped and piled, mounded and rounded and trenched." Art criticism had not yet considered the ques-tion of why the artists had planned these works for particular locations, and of the importance the location acquired thereby.

1965 — First protests in Washington and New York against the Vietnam War

1966 — Cultural Revolution in China

1966 — The National Organization for Women is founded in the USA

"sculpture as form –
sculpture as structure –
sculpture as place."

Carl Andre

6

7

site-specific art

One of the first site-specific earth sculptures was created in 1955 in Aspen, Colorado: the *Earth Mound* by Herbert Bayer (who also participated in the *Earth Works* exhibition). Bayer, a Bauhaus artist who had emigrated from Germany to America, was commissioned by the Aspen Institute for Humanistic Studies to design a lawn for its campus. Alluding to Indian grave mounds, he designed a geometrically shaped traversable area, produced on site by excavating and depositing earth, and by covering the resulting landscape with grass: Land Art before its time.

Site specificity is the distinctive characteristic of Land Art. The artists conceive the works for particular settings and create them on site. Thereby they alter the location's surface, structure, and materiality, and inscribe themselves in its memory. The works themselves are intrinsically immovable. In the words of the sculptor Richard Serra: "To remove the work is to destroy the work." This work's inevitable unsaleability was an affront to the art world. What could one acquire for a collection, what should one show in the galleries? Gerry Schum conceived his film *Land Art* solely for broadcast on television. Herbert Bayer could only present his *Earth Mound* in exhibitions by means of photography, a documentation medium that artists viewed with a mixture of rejection and distrust, indifference and pragmatism.

The most important thing to the artist was realizing the piece, not documenting or possibly selling the site-specific work. In February 1969 for the *Earth Art* exhibition, Cornell University's Andrew Dickson White Museum of Art in Ithaca, New York, commissioned American and European artists to produce their works in the museum's interior and exterior space. With a feeling for the artists' self-imposed ideals, the museum's director Thomas W. Leavitt defined his institution as a type of project space for art: "Earth Art is one facet of a general tendency among younger artists to renounce the construction of art objects in favor of the creation of art experiences related to a broad physical and sociological environment. If this tendency prevails, it could ultimately transform the entire structure of the art world. Museums wishing to support the efforts of contemporary artists may have to think increasingly in terms of backing projects rather than acquiring art objects or holding conventional exhibitions."

1966 — Works of Minimal Art shown in the exhibition "Primary Structures" in the Jewish Museum, New York

1967 — The "Summer of Love" marks the high point of the hippie movement

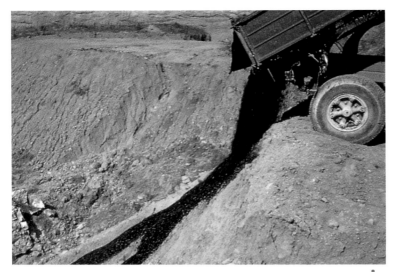

8. ROBERT SMITHSON

<u>Asphalt Rundown</u>
1969, Rome; a truckload of asphalt

9. ROBERT SMITHSON

<u>Enantiomorphic Chambers</u>
1965; painted steel, mirror, 61 x 76 x 79 cm
lost

8

New topographies

The new topographies of art – salt-water lakes, deserts, volcanoes, sandy beaches, highland areas and moors – offered possibilities that seemed far less restrictive than those the museum did. Their significance and meaning could shift depending on the observer's point of view. Claes Oldenburg demonstrated the importance of location in the heart of New York with his sarcastic piece *Placid Civic Monument*. For the *Sculpture in the Environment* exhibition, he had three professional gravediggers dig a human-body proportioned hole in Central Park on a Sunday morning, and then fill it up again three hours later. The sculpture could subsequently be seen only in a film Oldenburg had shot during the short action (a film he also showed at the *Earth Works* exhibition). The sculpture's renown, however, was due primarily to the daily press, and to art-scene word of mouth. Oldenburg provoked people and influenced their thoughts, which at the time circled incessantly around the topic of graves: from the museum as a funeral home for art, to the Vietnam war. "By not burying a thing the dirt enters into the concept, and little enough separates the dirt inside the excavation from that outside …"

The question of site specificity does not arise just for this type of performative work outside, however, but for any work conceived for a particular space. With Minimal Art's "specific objects" these spatial requirements of art had already been subject to critical examination since the 1960s, and thus they paved the way for the new site-specific projects of Land Art.

Minimal Art: neither painting nor sculpture

The American artist Donald Judd announced the parameters of the new art in his essay *Specific Objects*: "Half or more of the best new work in the last few years has been neither painting nor sculpture … Three dimensions are real space. That gets rid of the problem of illusionism and of literal space, space in and around marks and colors – which is riddance of one of the salient and most objectionable relics of European art." At issue here were the conventions of art forms. The crux of these comments was their novel location of minimalist objects in space, for viewers, without the illusion of pictorial space constructed according to the rules of perspective, are thrown

1967 — Marshall McLuhan publishes his cult book on media theory "The medium is the message"

1967 — Art critic Germano Celant coins the term Arte povera for an exhibition in Genoa

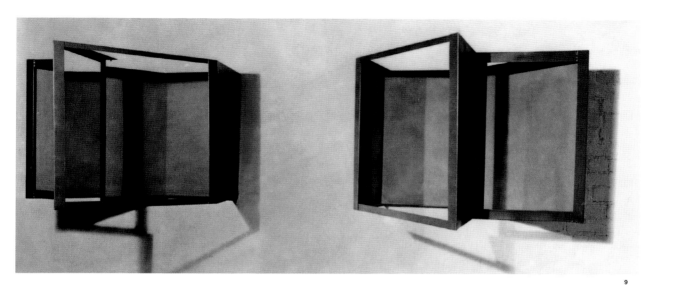

9

back into the here and now of their own gaze. Thus, works of Minimal Art are no longer oriented on perspective, have no particular visual focus, and do not rely on a particular viewpoint.

The 1966 exhibition *Primary Structures* in New York marked the baptism of Minimal Art in its orthodox form. The artists of Minimal Art included, among others, Carl Andre, Sol LeWitt, Robert Morris and Robert Smithson, who two years later would also participate in the *Earth Works* exhibition.

In the exhibition *Primary Structures*, Carl Andre showed his sculpture *Lever*, a row almost nine metres long of 137 commonly available bricks, laid out on the ground at a right angle to the wall. The unpretentious, aloof presence of the identically shaped separate components on the ground, and their simple arrangement in a horizontal sequence, transformed the museum space. Andre placed the accent decisively on the sculpture's material, which is present in the exhibition qua weight, mass, density and expansion. In order to illustrate his idea of sculpture, he described it metaphorically in terms used to describe landscape infrastructure, such as street, barricade, barrier or embankment.

Andre's statement "Sculpture as form – Sculpture as structure – Sculpture as place" was pioneering for Land Art. This statement was a declaration of his version of art's site-specificity: "It is futile for an artist to create an environment because you have an environment around you all the time. Any living organism has an environment. A place is an area within an environment which has been altered in such a way as to make the general environment more conspicuous. Everything is an environment, but a place is related particularly to both the general qualities of the environment and the particular qualities of the work that has been done."

The short path from indoor Minimal Art to the new site-specific works of outdoor Land Art is reflected by Andre's artist colleagues Robert Smithson and Walter De Maria: not in this type of fundamental programmme of "sculpture as place", but rather in a certain eccentricity of sculptural forms.

Smithson had conceived objects such as the *Enantiomorphic Chambers*, which he intended as an attempt to obliterate the viewer: "The surface plane (fluorescent green) is behind the framing support (blue). One cannot see the whole work from a single point of view, because the vanishing point is split and reversed. The structure is flat, but with an extra dimension … The chambers cancel out one's reflected image, when one is directly between the two mirrors." The viewer, however, was soon to return in Smithson's works.

1967 — Joseph Beuys founds the Deutsche Studentenpartei (German Student Party)
1968 — Student protests in Paris reach a high point in May 1968 — Massacre of Vietnamese civilians by American soldiers in My Lai

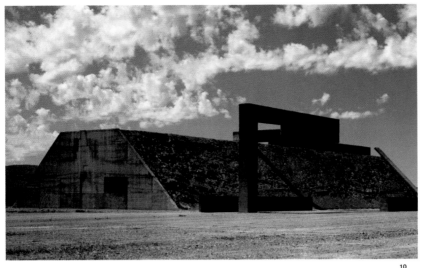

10. MICHAEL HEIZER
<u>Complex One, Garden Valley</u>
1972–1976, Nevada; concrete, steel, earth,
ca. 7.20 x 42.70 x 33.50 m
Collection of Michael Heizer and Virginia Dwan

11.
<u>Richard Long Sculpture</u>
1969, Galerie Konrad Fischer invitation card
Sammlung Marzona, Kunstbibliothek,
Staatliche Museen zu Berlin

12. RICHARD LONG
<u>Berlin Circle</u>
1996; grey slate, ca. 1200 pieces, Ø 12.45 m
Sammlung Marx, Nationalgalerie im Hamburger
Bahnhof, Staatliche Museen zu Berlin

10

The piece Smithson chose to exhibit in the *Earth Works* exhibition was entitled *Nonsite, Franklin, New Jersey*. In five progressively larger wooden boxes, he placed limestone that he had collected from five locations around the Franklin Furnace Mines. A text and perspectively tailored aerial photographs of the area complete the "Nonsite". While the serial structure, scale, and perspectival arrangement are already familiar from Smithson's minimalist objects, integrating the collection of stones in the boxes is new. Viewers also find themselves in a new role when they are called upon, in the text, to venture outside and visit the five locations where the materials were found. "Tours to sites are possible. The five outdoor sites are not contained by any limiting parts – therefore they are chaotic sites, regions of dispersal, places without a room …"

The third protagonist of Minimal Art and Land Art, Walter De Maria (also a participant in the *Earth Works* exhibition) chose a completely different path than Andre and Smithson. De Maria is particularly known for his *Lightning Field* of 1977. Four hundred industrially manufactured stainless steel rods stand on an area one mile (1.609 km) by one kilometre in a remote desert region in New Mexico. This region's frequent thunderstorms produce spectacular discharges on the metal rods, a sublime natural spectacle.

The work's playful and simultaneously provocative aspects and the perfect industrial finish of the metal were also characteristics seen in his early minimal works and in his *Museum Piece* of 1966. The geometric form of the Swastika – an Indian symbol for the sun disc or wheel of life – inevitably reminds viewers of the political symbol of the Nazis. The (politically incorrect) symbolism, however, is broken by the apparent invitation to play with the movable sphere in the sculpture, and by the work's illustrious museum location. Such games are not permitted in the museum, however, since one is not allowed to touch the object. Is it thus a forward-looking comment by De Maria about the museum as a venue for art?

In his search for new forms and different venues for art, De Maria pursued radical concepts more intently than almost any other 20th century artist. Several years before the expressions Land Art and Earth Works entered the discourse, he had already outlined projects of fantastic dimension that left museums and their closed rooms far behind.

1968 — Walter De Maria installs the "Earth Room" in the Heiner Friedrich gallery, Munich
1968 — The Dwan Gallery in New York shows "Earth Works"

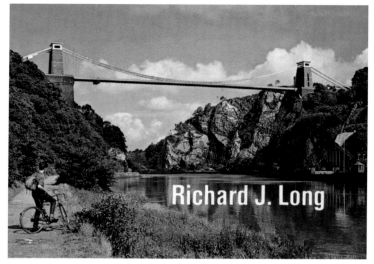

Richard J. Long

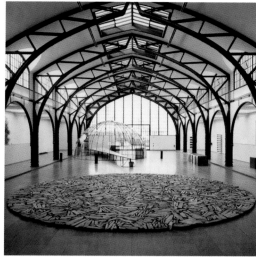

"I like the simplicity of walking, the simplicity of stones."

Richard Long

catastrophes of art

Walter De Maria's manifest of May 1960, based on the threatening aspects of the elements of nature, is entitled *On the Importance of Natural Disasters*: "I like natural disasters and I think that they may be the highest form of art possible to experience … If all of the people who go to museums could just feel an earthquake. Not to mention the sky and the ocean. But it is in the unpredictable disasters that the highest forms are realized." In his text *Art Yard* from the same year, De Maria designed a scenario for an apocalyptic Happening with slightly out-of-control bulldozers and excavators: "I have been thinking of an art yard I would like to build. It would be sort of a big hole in the ground. Actually it wouldn't be a hole to begin with. That would have to be dug." De Maria describes how the invited art lovers, in a choreography of explosions and construction machinery, begin to dig. This was undoubtedly a parody of Happenings, even though the appeal to the construction company formulated at the end of the text, that their work was a contribution to the creation of a true garden of art, is more than just a playful punch-line.

Eight years later De Maria opened a memorable installation in the Heiner Friedrich Gallery in Munich. 45 cubic metres of black earth were evenly distributed over 72 square metres of the gallery space. A glass panel approximately one metre tall provided a view of the earthen area, but also prevented access to the room. This was a provocation, an absolute zero, because viewers could not enter the gallery, and the earthen material had laid waste to the art venue. De Maria had announced his lofty aspirations on the exhibition poster with the words "Pure Dirt – Pure Earth – Pure Land", thereby indicating that the installation was to be understood as a contemplation and meditation room vacillating between irony and emphasis. "God has given us the earth, and we have ignored it," De Maria reminds in his press release. The artist barricaded the space for art, and presented himself as a voice in the wilderness.

He was not alone in this. Around 1970 one could find "wilderness" everywhere – such as in images of the surface of the moon or the films of the Italian Neo-realist directors Pier Paolo Pasolini and Michelangelo Antonioni – as the building site for spectacular Earth Works. Michael Heizer commissioned the excavation of tons of earth in the Nevada desert for his negative sculptures *Nine Nevada Depressions*. Robert Smithson created his coiled earth sculpture *Spiral Jetty*, almost 500 metres long, in a remote saltwater lake in the desert of Utah. The desert stood for boundless emptiness, death and tempta-

1968 — The magazine "Artforum" publishes the programmatic essays "Antiform" by Robert Morris and "A Sedimentation of the Mind: Earth Projects" by Robert Smithson 1969 — On July 21st, Neil Armstrong becomes the first person on the moon

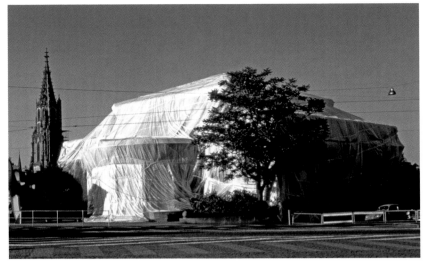

13. CHRISTO AND JEANNE-CLAUDE
<u>Wrapped Kunsthalle, Bern</u>
1968, Bern; 2430 m² polyethylene,
3050 m nylon rope

13

tion, but also for revelation, purity and purification. Viewers, if they managed to reach the faraway desert locations, had the choice of meanings.

In the years from 1972 until 1974, Heizer arranged the construction of *Complex One* in the Nevada desert. This was a pile of earth more than forty metres long and around seven metres high, bordered on its narrow side by trapezoidal, steel-reinforced concrete walls. *Complex One* is part of the larger project *City*, on which Heizer is still working today, with the support of the American Dia Art Foundation and the Lannan Foundation. It is reminiscent of prehispanic temple grounds and sacrificial places in Mexico, or of Egyptian graves and pyramids. Yet the atmosphere of threat is caused above all by the fact that the restricted military zone of Nellis Air Force Range and atomic testing area begins only forty kilometres southwest. In 1976 Earl C. Gottschalk, a *Wall Street Journal* reporter, described this feeling in the desert: "I'm here thirty miles downwind from the U.S. atomic-testing site in a godforsaken, barren desert to view, of all things, an exhibit of modern art … The artwork I'm looking at cost $100,000 to make and is highly praised by New York art critics, but it isn't for sale. It can't be moved. It weighs 500 tons, and only a handful of people have ever seen it. It's called *Complex One*, and it's an earthwork."

The expression "earthwork" remained ambivalent. It did not take on the connotations of the satisfying and appeasing slogan "back to nature". On the contrary, in the press it had the ring of madness, sensationalism, power, money and genius. It served the artists, just like their desert venue, as a concept. "The desert," wrote Smithson, "is less nature than a concept, a place that swallows up boundaries. When the artist goes to the desert he enriches his absence and burns off the water (paint) on his brain. The slush of the city evaporates from the artist's mind as he installs his art … A consciousness of the desert operates between craving and satiety."

walking as art

In contrast to the costly desert projects, British artists invented a much simpler art. For *A Line Made By Walking England 1967*, Richard Long walked back and forth on a lawn until he had worn a straight line into the ground, which he then photographed from the front. For his contribution to Gerry Schum's film *Land Art* he created the piece *Walking a Straight 10 Mile Line Forward and Back – Shooting Every Half Mile*. Once again, Long followed a particular path,

1969 — U.S. President Nixon announces the first troop withdrawals from Vietnam
1969 — On April 15th, the television exhibition "Land Art" is shown on Germany's channel 1 at 10:40 p.m.

16

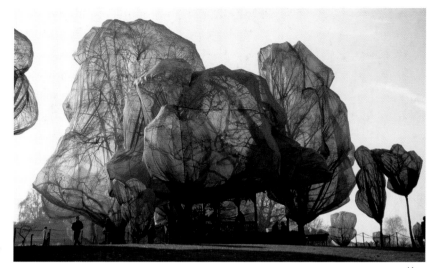

14. CHRISTO AND JEANNE-CLAUDE

<u>Wrapped Trees</u>
1997–1998, Fondation Beyeler and Berower Park,
Riehen; 178 trees, 55,000 m² woven polyester fabric,
23.1 km rope

but this time the line was not marked by the traces of walking and then photographed. He took still shots at half-mile intervals, zooming slowly into the landscape's depths, and then edited the results into a continuous film sequence. One can additionally hear Long's steps and his laboured breathing in the film's soundtrack. Although the artist's ten-mile walk along a straight line is recorded both as a sequence of images and as sound, the line identified in the title remains imaginary and exists only in the minds of viewers.

When Long hiked in remote regions, moors, deserts or high mountain areas, and formed lines or circles made from his own footprints or from lines of stones, the question arose of how to represent these sculptures in other locations. How can walking become art?

During his hikes, Long collected materials he found en route, and then laid them out in the forms of simple geometric lines or circles in the interior spaces of galleries and museums. He primarily used stones, but also used branches, sticks, turf, mud and water. His works are simple, and he believes this is as it should be. "I like the simplicity of walking, the simplicity of stones. I like common materials, whatever is to hand, but especially stones. I like the idea that stones are what the world is made of. I like common means given the simple twist of art. I like sensibility without technique." In his search for the simplest

and most direct form, Long has also used photographs that he collages on cardboard and then presents, providing hand-written indications of title, location, and time of the hike. "Even though it is necessary to get a good photograph," declared Long in an interview, "the photograph should be as simple as possible so that when people look at the photograph they are not dazzled by wide-angled lenses or special effects. Because my art is very simple and straightforward, I think the photographs have got to be fairly simple and straightforward …" It is precisely the simplicity of Long's works that evokes the intrinsically complex experiences and encounters that a hike includes. They are, as the Belgian artist Marcel Broodthaers says, "poetry".

It is therefore not surprising that Long has also worked with printed matter. His numerous artist books and invitation cards initially appear as familiar as common photo albums and postcards, yet Long uses the look of the familiar to introduce something new.

During a hike in January 1969, Gerry Schum photographed marks that Long had made in the barren Dartmoor landscape. Financed by the art-collecting couple Visser, he used this series of photographs to create an artist's book entitled *Sculpture by Richard Long Made for Martin & Mia Visser*. Thus the book became sculpture.

1969 — The Andrew Dickson White Museum of Art in Ithaca, New York, presents "Earth Art"
1969 — The John Gibson Gallery, New York, shows "Ecological Art"

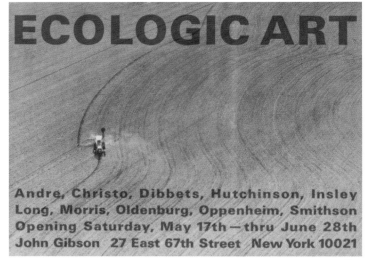

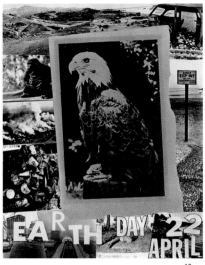

15

16

For his first solo exhibition at Konrad Fischer's gallery, Long had his name and the date of the exhibition stamped on a postcard of the hanging bridge near Clifton in Bristol. He appropriated the photo on the postcard, and his name could be associated with the landscape as much as with the cyclist in the image's foreground. The question, at that moment still unresolved, of why an invitation to an exhibition entitled *Sculpture* would depict a postcard from Bristol, was answered upon viewing the installation in the gallery. The exhibited sculpture consisted of nothing more than thin wooden twigs, which Long placed lengthwise in the gallery space. He had collected this material during a hike in Bristol, the place indicated on the invitation.

For his books, Long also applies a similar strategy of using familiar and simple means. The twenty pages of the slim artist's book *From Around a Lake* show photographs of the leaves of twenty green plants. Their arrangement on the book's pages varies, with the plant leaves sometimes also arranged into ornamental patterns on the page. Through the familiar medium of the book, its title, and the pictures' insistent austerity, this unusual botanical inventory becomes poetic research, simple and direct, into a walk around a lake.

Long's works characterize the European antithesis to the spectacular and monumental earth sculptures of the deserts of America.

Walking and collection are cautious methods of approaching, perceiving, and adapting oneself to the landscape. Andy Goldsworthy and Hamish Fulton pursued similar concepts, even though they set their accents differently. Goldsworthy primarily worked with natural materials that he found in the landscape, and then arranged into fragile, symbolic forms. Thereby photography held purely documentary rather than conceptual significance for him. Fulton worked with framed photo-text pieces on the other hand, and did not arrange natural materials indoors. For all their differences, neither of these two artists worked in a studio, and they both avoided using technical aids. They equipped themselves with only a camera and their preferences for the poetic simplicity of Japanese Haiku.

ecological art

In May 1969, the John Gibson Gallery in New York presented the exhibition *Ecological Art*. On the invitation card, Dennis Oppenheim's eloquent motif *Directed Seeding – Wheat* promoted the new dimensions in artistic work. Once again, Carl Andre, Robert Morris, Claes Oldenburg, Dennis Oppenheim and Robert Smithson participat-

1969 — The exhibitions "Op losse schroeven: Situaties en cryptostructuren" in Amsterdam and "Live in Your Head: When Attitudes Become Form" in Bern focus on new trends in art 1969 — Earth Art projects are presented in the exhibition "557 087" in Seattle, organized by Lucy Lippard

15.

<u>Ecological Art</u>
1969; John Gibson Gallery invitation card,
New York
Sammlung Marzona, Kunstbibliothek,
Staatliche Museen zu Berlin

16. ROBERT RAUSCHENBERG

<u>Earth Day</u>
1970; poster, 86 x 64 cm
Sammlung Marzona, Kunstbibliothek,
Staatliche Museen zu Berlin

17. ROBERT MORRIS

<u>Grand Rapids Project X</u>
1973–1974, Belknap Park, Grand Rapids, Michigan;
earth, asphalt, length 145.70 m each, width 6 m

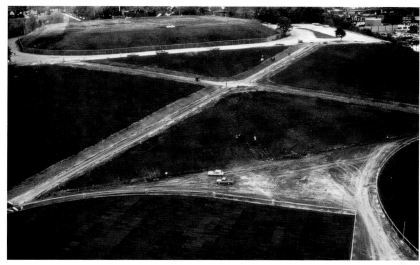

17

"ınstead of using a paintbrush
to make his art, ʀobert ᴍorris would like
to use a bulldozer."

Robert Smithson

ed. Additionally, works by Christo and Jeanne-Claude – whose work can by no means be categorized, however, with the term Land Art – Jan Dibbets, Peter Hutchinson, Will Insley and Richard Long were also included. Once again, the exhibition was an improvised show of photo montage, drawings, texts, and models in the gallery space.

Gallerist John Gibson invented a label for the space that recalled an office more than a gallery: "Projects for Commissions". He saw himself as a broker for new, sensational art projects, and his appeal to the curiosity of the press was not in vain. Even fashion magazines such as New York's *Mademoiselle Magazine* wished him only the greatest success: "But John Gibson, Projects for Commissions (name of his gallery) is unique. 'Projects' is the tip-off word. The new direction in art, he says, is actually the project, the idea … the idea itself is beautiful, is a work of art."

On request Gibson sent photographs, on the back of which he noted information about the model, the material, and the size of the project. One could purchase the model exhibited in the gallery, or finance the completion of the generally expensive projects. Gibson explained to the press, "You could almost call me an idea broker and not an object merchant. Essentially, I'm dealing in monumental objects – or, rather, ideas for monumental objects. Primarily, the purpose of

this place is to devise projects for public and corporate commissions – monumental works by contemporary artists – and to show ideas. Originally, I thought of making this a room with no art – that is, no art objects – on display at all … just slides and movies of ideas projected onto the walls."

Peter Hutchinson introduced his tube projects here, with which he wanted to call into question the scientifically founded opposition between organic and inorganic materials. He filled Plexiglas tubes with such varied materials as algae, bread and cacti, which through interaction with light and water either grew or began to mould. As a site-specific project, he additionally planned larger-dimensioned tubes for deserted landscapes on the edge of volcanoes, icebergs, deserts or mountains. "If the site was fertile," recalled Hutchinson later, "I added tubes with chemical crystals; if inhospitable to life I used tubes with growing cultures of bacteria, spores or moulds." The tube projects were only realized as models and photo collages, however, as no one commissioned them.

Much more successful were Christo and Jeanne-Claude, an artist couple who introduced their project *Packed Tree* in the John Gibson Gallery. Christo and Jeanne-Claude had already carried out several variants of this project – among their earliest interventions in

1970 — The "New York Art Strike" arises as a protest against US politics events celebrating the first "Earth Day"

1970 — On April 22nd over 20 million people participate in 1970 — The National Guard kills demonstrators at Kent State University, Ohio

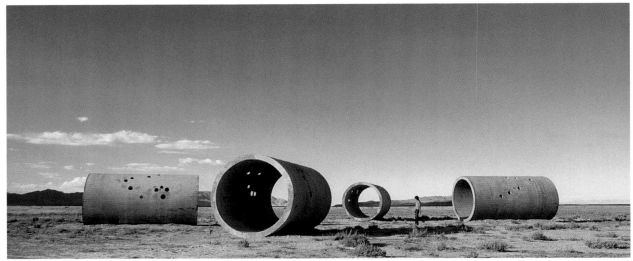

18

nature. In 1966 they had exhibited a ten-metre long wrapped tree on the floor of the Van Abbemuseum in Eindhoven, Holland. The crowns of forty trees in Forest Park were to be wrapped for the Saint Louis Museum of Art. In 1968 – during Christo's solo exhibition at the Museum of Modern Art in New York – they proposed a project for the museum's garden. In 1969 two *Packed Trees* were created in Sydney, Australia, for the collection of John Kaldor. In the same year, the artists attempted to wrap 330 trees on the Avenue des Champs-Elysées in Paris, but were unable to overcome the opposition of Maurice Papon, the Prefect of Paris at that time. Since 1958 Christo has wrapped an impressive number of objects, binding them in ordinary fabric. He simply wrapped everything: tins, magazines, chairs. From 1961 Christo and Jeanne-Claude even wrapped whole buildings: from the museums in Chicago and Bern to the German Reichstag in Berlin.

All of these artists had to learn to look after questions of financing, commissions, construction plans, permits, and public presence. John Gibson saw his gallery as a forum for artists seeking commissioning parties. This business-minded idea broker invented another term, to add a fourth label to Land Art, Earth Works and Earth Art: Ecological Art. He commissioned Dan Graham, who did not participate as an artist in the *Ecological Art* exhibition, to write a text for the

catalogue. In his unconventional draft that he was never to publish, Graham attempted a detailed definition of "place". Using the exhibited projects as examples, he enumerated the broad spectrum of meanings that "place" could hold for the work.

On the other hand, Graham explained the word "ecology" very simply and concisely in one sentence: as the study of the relationship of all bodies to their environment. The interests of the artist and of the gallerist differ in this point, although Gibson undoubtedly had a feeling for the trends of the time. In 1962 the environmental activist Rachel Carson published her book *Silent Spring*, in which she denounced long-term environmental damage. In April 1970 more than twenty million people celebrated the first *Earth Day* in the USA. In 1971 the first Greenpeace protests against an atomic test in the North Pacific began, using their ship the Phyllis Cormack. Nevertheless, none of the artists exhibited by Gibson wanted their projects to be understood at that time in such a demonstrative, ecologically engaged context. Robert Smithson summarized many of his colleagues' reservations when he complained that the ecologists tended to view landscape in categories of the past.

The legally established program that had existed since the 1950s for regenerating areas destroyed by resource excavation pro-

1970 — Gerry Schum's television exhibition "Identifications II. Fernsehausstellung" is broadcast on German television
1970 — Germano Celant organizes the exhibition "Conceptual Art, Arte povera, Land Art" in Turin

18. NANCY HOLT

<u>Sun Tunnels</u>
1973–1976, Great Basin Desert, Utah;
4 concrete tubes with drilled holes, Ø 2.80 m,
length 5.50 m, weight 22 tons
Collection of Nancy Holt

19. ALICE AYCOCK

<u>Low Building with Dirt Roof (for Mary)</u>
1973, New Kingston, Pennsylvania; wood, stone,
earth, height ca. 75 cm, width 6 m, depth 3.70 m
Collection of Alice Aycock

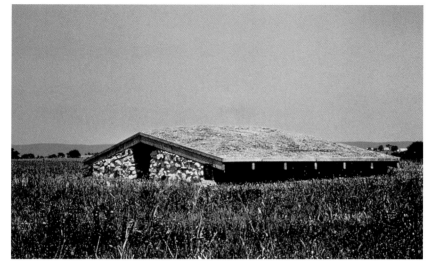

19

vided impetus for ecologically oriented art in the USA. In 1973 Robert Morris carried out the first extensive earthwork commissioned by officials in the context of this program. Highway construction had broken up the property of today's Belknap Park in Grand Rapids, Michigan.

For an earthen hill in the park, Morris developed his *Grand Rapids Project X*, which envisioned two evenly rising asphalt paths that crossed halfway up the hill. On one hand, the extremely simple design was suitable for summer walks, and for winter skiing and sledding, and thereby responded to a central requirement of park users. On the other hand, the slightly displaced cross form of the "X" is a simple and unified figure, typical of Morris' version of Minimal Art. He intended the artistic intervention to give the property its own structure again, and to cater to specific uses.

Yet Morris was certainly aware of the ambivalence of this type of re-cultivation, and one can view his *Grand Rapids Project X* as a prototype for "environmental projects" in which the changes caused by infrastructural encroachment or industrial exploitation can be repaired, but are not intended to be disguised. The asphalt material of the pathways and the simple form of the "X" tend to disclose the ecological devastation rather than conceal it.

Direct, ecologically motivated actions remain more the exception in Land Art, such as Alan Sonfist's *Time Landscape* or Agnes Denes' *Wheatfield – A Confrontation*, for example. Within a defined timeframe, these artists considered alternative means of cultivating the earth in urban areas. Denes planted and harvested wheat on an empty lot in Manhattan, while Sonfist planted and tended a garden on a parcel of land in Manhattan's cramped urban labyrinth. Although such controversial actions only attracted temporary attention in the press and were not recorded in the chronicle of art exhibitions, they provided important stimuli to Land Art, as can be seen in the design of new monuments.

new monuments

The self-imposed ideal of site-specific art created scope for the development of artists' work. Land Art's first pioneering exhibitions did not have any female participants. Since the mid-1970s, however, works for specific locations by artists such as Alice Aycock, Nancy Holt, Patricia Johanson and Mary Miss have attracted more attention from art critics, who recognized the radically new aspects of their artistic methods.

1970 — Robert Smithson erects the earth sculpture "Spiral Jetty" on the Great Salt Lake, Utah

1971 — First Greenpeace actions with the ship Phyllis Cormack to protest an imminent US atomic test in the North Pacific

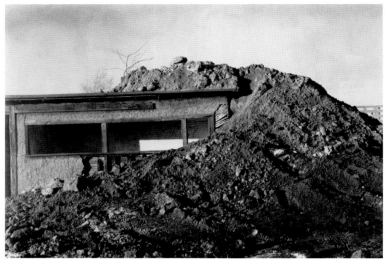
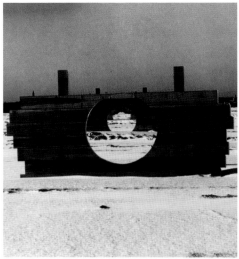

20

21

Between 1973 and 1976, Nancy Holt developed her *Sun Tunnels* for a site in the Utah desert. These consist of four big concrete tubes, each almost six metres long and three metres wide, positioned to form two intersecting axes. As in an observatory, she aligned the tubes to correspond to astronomical calculations. The axes correspond to the summer and winter solstices, so that the sun rises and sets in the tubes. All four concrete elements have holes drilled in them, the patterns of which correspond to the star patterns of four constellations. She intended these monuments, each of which weighs 22 tons, to focus the gaze on the desert panorama. As Holt said in an interview, "The panoramic view of the landscape is too overwhelming to take in without visual reference points. The view blurs out rather than sharpens. Through the tunnels, parts of the landscape are framed and come into focus."

In 1973 Mary Miss conceived a temporary work for Battery Park at the southern tip of Manhattan. Planning for the landfill had been developed at the end of the 1960s, yet at the beginning of the 1970s it was still one of the largest undeveloped spaces in Manhattan. Like Holt, Miss worked towards focusing the gaze, but she intervened in metropolitan space and urban contexts, and used wood instead of concrete. Out of a row of five tall walls made of wooden planks and

lined up behind one another, she cut circular areas of equal radius but with progressively lower central points. The work frames the viewer's gaze across the empty lot and towards the city, accelerating it by means of the circular segments' displacement.

Other artists also worked with irritation of the gaze and with the viewer's motion. In 1973 Alice Aycock designed the *Low Building with Dirt Roof (for Mary)* for the Gibney Farm in New Kingston, Pennsylvania. Thereby she was citing the earthwork *Partially Buried Woodshed* by Robert Smithson, who in January 1970 buried a wooden hut under twenty truckloads of earth on the grounds of Kent State University. Aycock not only buried her building under a layer of earth on the roof, however, but also sunk it into the ground. In the sloping ground the roof became a new artificial horizon line and intensified the feelings of constriction and danger in the building. As the artist said: "The body posture of anyone moving into the building ranges from a crouched hand-and-knees to a flat horizontal position on the ground. The sense of claustrophobia inside is increased by the knowledge that the exterior surface of the roof is covered by a mound of earth (approximately 7 tons)."

Patricia Johanson has been working since 1969 with linear and geometrical structures and patterns, which she develops in drawings

1971 — **Robert Morris builds "Observatory" as his contribution to the exhibition "Sonsbeek '71" in Emmen**
1972 — **"documenta 5" exhibition in Kassel, curated by Harald Szeemann**

20. ROBERT SMITHSON
<u>Partially Buried Woodshed, January 1970</u>
1970, Kent State University, Ohio; wooden hut,
20 truckloads of earth, ca. 5.60 x 3 x 13.70 m

21. MARY MISS
<u>Untitled</u>
1973, Battery Park City Landfill, New York;
5 wooden barriers, 3.65 x 1.82 m each,
at 15 m intervals

22. PATRICIA JOHANSON
<u>Cyrus Field</u>
1970–1971, Buskirk, New York; redwood, marble,
cement, area 1.2 ha

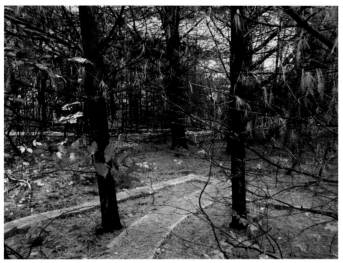

22

and executes using various materials and in monumental size. "I saw," wrote Johanson in retrospect, "that by using the line as a compositional basis you could incorporate nature intact, without displacing or annihilating anything else. So the line became a strategy for creating non-intrusive, interwoven structures that could be as large as you wished ..." One can only surmise the linear origins of the marble, wood and cement version of *Cyrus Field* in a wooded area near Buskirk, New York. The natural cycle of the seasons has weathered the materials laid on the floor of the woods, and they have adapted themselves to their surroundings to such an extent that they exist on the boundary between art and nature.

Other artists such as Dani Karavan, Charles Ross and James Turrell have been working since the 1970s on projects for monumental landscape installations. In museum spaces, Turrell constructed room installations intended to make light physically experienceable. The context of perceivable spatial depth dissolves and creates the impression that it exists in a boundless environment of pure, coloured light. Turrell's light objects, light projections and light spaces deal thematically with vision and the interaction between perception and illusion; he has planned what is surely his most complex light project, however, for the outdoors. The *Roden Crater* is a volcano around 70 km north-west of Flagstaff in northern Arizona. Since 1974, Turrell has been designing a system of rooms, passageways, and lookout points for this volcano. In this strangely silent, lonesome location where only the wind is to be heard, the installation's primary purpose is the intensive perception of light. The various tunnel passageways function on the principle of a Camera Obscura. In specific positions, the sun, moon and planets cast their light in such a way as to project their image on screens at the ends of tunnels in the volcano's interior. Turrell compared the effect to that of the sublime experience of flying: "The crater space is formed to support and make malleable the sense of celestial vaulting ... As you proceed up the inside slope toward the rim, the celestial vaulting will no longer attach to the crater rim, but will expand out to the far horizon. The largest amount of space is experienced when you reach the rim of the crater."

Gallerist John Gibson's business model, intended to attract commissioning parties for artistic projects, has clearly developed its own dynamic. The large-scale projects by Heizer, Ross and Turrell, however, have grown to dimensions barely feasible for private patrons or foundations to finance. The departure from the gallery and museum "white cube" came burdened with a high mortgage.

1972 — Land Art and Earth Works projects for the Munich Olympics

1972 — Michael Heizer begins construction of "City" in the Nevada desert

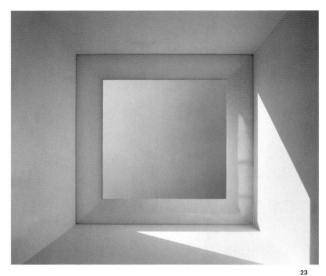

23. JAMES TURRELL

Sky Space I
1974, Villa Panza, Varese; fluorescence and
exterior light, portal size 2.54 x 2.54 m,
room size 6 x 3.60 x 3.60 m
Solomon R. Guggenheim Museum, New York,
Panza Collection, gift, 1992, on permanent loan
to Fondo per l'Ambiente Italiano

24. JAMES TURRELL

Roden Crater
since 1977, Flagstaff, Arizona; volcano crater
Collection of James Turrell and the Dia Art
Foundation, New York

23

Beyond the white cube

One feature of Land Art is its preoccupation with the tradition of sculpture, which has taken a new direction since the era of Minimal Art. Sculpture could be an excavation, a field of metal rods, a buried hut, a trace left in grass, or a book. Another characteristic of Land Art is that the work is produced out-of-doors. This in no way means that exhibitions are no longer held in galleries and museums. The works are uncompromisingly conceived, however, for specific locations. In exhibitions, one could only show drawings, plans, texts, models, photographs and films of the projects. The French artist Daniel Buren criticized the tendency to continually exhibit without ever considering the question of the exhibition's location, but this criticism does not apply to Land Art, for there the exhibition's location is a focus of attention.

In a series of essays in 1976, the Irish artist and critic Brian O'Doherty applied the label "white cube" to the rooms of galleries. His description pertains to the rooms' emptiness and cleanliness, their dampened sound and closed windows, and their electric lighting and aseptic white wall colour. Such rooms seems like protective cells keeping all factors of everyday life at bay. Only thus do they secure the perception of art as an aesthetic phenomena related only to itself.

According to the credo of the influential American art critic Clement Greenberg, painting and sculpture should occupy themselves solely with the conventions of their forms and materials in order to divine their own, unalterable elements. The walls of the gallery thus become necessities that appropriate and change everything hung upon them into art. O'Doherty sees site-specific projects as an attempt to escape from this prison of art.

In retrospect, he judges the results sceptically. "How does the artist find another audience, or a context in which his or her minority view will not be forced to witness its own co-optation? The answers offered – site-specific, temporary, nonpurchasable, outside the museum, directed toward a nonart audience, retreating from object to body to idea – even to invisibility – have not proved impervious to the gallery's appetite."

Such scepticism may be appropriate. Galleries and museums are, as always, the venues of art. Yet Land Art formulates the question that first provoked this scepticism towards the site of the exhibition. Once again it was Robert Smithson, in the protest over documenta 5 exhibition practices, who put into words the danger of neutralization, and the refractory potential of art. "Cultural confinement takes place when a curator imposes his own limits on an art exhibition, rather

1973 — Robert Smithson dies in a plane crash

1973 — Lucy Lippard publishes the collection of materials "Six Years: The Dematerialization of the Art Object"

"over the last ten years rather surprising things have come to be called sculpture …"

Rosalind Krauss

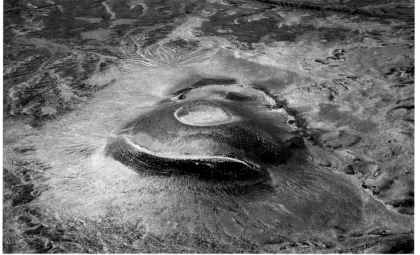

24

than asking an artist to set his limits … Museums, like asylums and jails, have wards and cells – in other words, neutral rooms called galleries. A work of art when placed in a gallery loses its charge, and becomes a portable object or surface disengaged from the outside world. A vacant room with lights is still a submission to the neutral … It would be better to disclose the confinement rather than make illusions of freedom. I am for an art that takes into account the direct effect of the elements as they exist from day to day apart from repre-sentation."

1974 — James Turrell begins construction of "Roden Crater" in Arizona

1975 — Charles Ross begins planning the "Star Axis" observatory in New Mexico

Log Piece, Aspen 1968

Temporary installation of 21 wooden beams, length 35–40 cm each

"I'm interested in art which is not in culture."

Carl Andre

b. 1935 in Quincy (MA), USA

At the beginning of the 1960s, Carl Andre expanded the concept of sculpture by adding the new dimension "clastic". He understood this expression in the sense of "can be put together or taken apart" from "broken or pre-existing parts". He used this to refer to his method of taking a series of mechanically finished components and laying them on the floor; a horizontal process of creating a sculpture in which every single part could replace any other part. In Aspen, Colorado, even at that time one of the most popular ski destinations in the USA, Andre laid a series of heavy, hewn wooden beams directly on the forest floor. The 21 beams, each about half a metre long, were not connected to one another, and they largely blended in with the unevenness of the ground. As Andre pointed out in an interview, the wooden beams harmonize with their environment, working together with nature rather than challenging it. Nevertheless, the work was simply the result of a picnic, and for him no more than a fortuitous exercise in creating an outdoor sculpture in the woods.

Log Piece, Aspen 1968 is no longer extant, and is only documented in photographs by Adam Bartos. Nevertheless, it became a representative motif of Land Art due to frequent reproduction in magazines and books, and through presentation of the photographs in exhibitions. This was because it demonstrated the influential idea of site-specific sculpture, as well as a new role for the artist in society.

Andre only carried out a few works outdoors, but those few pieces decidedly promoted his self-perception as one of the first "post-studio artists". For him the studio had become a questionable place to work, where one designed and executed artistic works in order to exhibit them in other locations and other contexts. *Log Piece, Aspen 1968* was a continuation of Andre's search for a form of sculpture that should take on, by his own account, the topographical qualities of a map, a street, or an embankment. Without a particular viewing angle, the sculpture now no longer visually resolved itself from just one viewpoint. Due to its simple, solid materiality, it demanded the viewer's attentiveness to both the surrounding location and to the specific spot it occupied.

In his statement "Sculpture as form – Sculpture as structure – Sculpture as place" Andre, who often expressed his understanding of sculpture, explained his manner of continuing the tradition of sculpting. The expression "place" in his work is ambiguous and vacillating, however, because he uses it to refer to the presentation's concrete, specific location, and as a general expression for the location's economic and political aspects.

Andre posed demonstratively before the photographer for *Log Piece, Aspen 1968* in order to illustrate his freedom from the interests of collectors, galleries and museums. The artist's provocative attitude, indebted to the new method of site-specificity, is reflected in the trio of adjectives he used to describe his work just a few years later: "My work is atheistic, materialistic, and communistic. It's atheistic because it's without transcendent form, without spiritual or intellectual quality. Materialistic because it's made out of its own materials without pretension to other materials. And communistic because the form is equally accessible to all men."

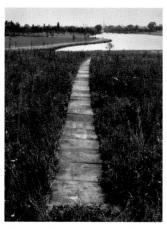

97 Steel Line for Professor Landois, Münster 1977

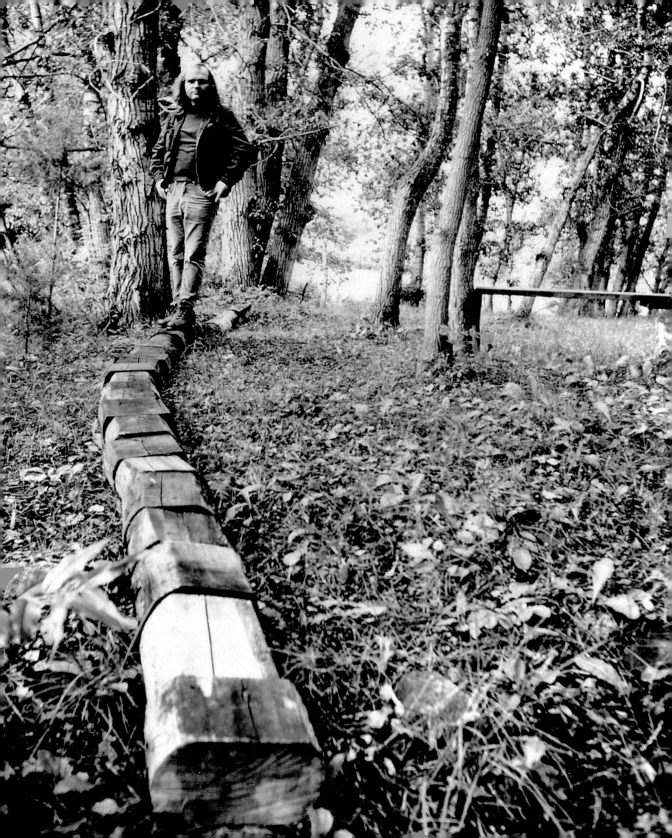

Project for a simple Network of underground wells and Tunnels

Merriewold West, Far Hills, New Jersey; concrete, wood, earth, 8.50 x 15 x 2.70 m
Collection of Alice Aycock

b. 1946 in Harrisburg (PA), USA

The artist and art historian Alice Aycock works on the narrow boundary between sculpture, architecture and landscape design. When the art critic Rosalind Krauss, in a pioneering essay in 1979, coined the phrase "sculpture in the expanded field", she was primarily referring to Aycock's work of the 1970s, which eludes any categorization into an art genre.

In 1975 Aycock was invited to participate in the exhibition *Projects in Nature: Eleven Environmental Works*. Eleven artists, including Carl Andre, Susan Eder, Richard Fleischner and Roelof Louw, were to produce works on an open area approximately 50 hectares in size. Aycock's contribution, *Project for a Simple Network of Underground Wells and Tunnels*, is a simple but very effective network of underground shafts and tunnels made of concrete. A sunken wall encloses the site in which the work's six concrete-block shafts are located. Three of these shafts are not accessible, and three serve as an entrance to the underground tunnel system. Lifting the wooden lid and climbing down the ladder of one of these accessible shafts, one finds oneself in a narrow tunnel just 80 cm wide and 70 cm high. From there one can only creep arduously through the passage to the next shaft opening, or else turn back.

In the exhibition's accompanying catalogue Aycock cites many references from silent film, literature and art history, with which she lends her work a broad spectrum of meaning: scenes from Friedrich Wilhelm Murnau's *Nosferatu*, H. Rider Haggard's adventure novel *She* and Edgar Allan Poe's *The Pit and the Pendulum*. She also cites art historical works dealing with ancient mystery rooms, grave buildings and bunkers.

Yet when they enter the underground network, every viewer will develop their own associations not necessarily conditioned by the intellectual culture of horror. In fact, Aycock uses the simplest elements to construct interwoven, claustrophobic situations that confront the viewer with panicky feelings of constriction, threat and isolation. In an interview, Aycock stressed that Minimal Art objects had a great influence on her in this respect, particularly the physically demanding works of Robert Morris and Bruce Nauman. "Minimalism had an effect on me, in that it was the prevailing ideology when I was a student ... It was a point of departure for me in that there were certain aspects of minimalism – it exists in the space of the viewer, it takes up real time and space, and you confront it with your body rather than it's being an object on a pedestal – which I responded to very strongly."

Minimalism's concept of withholding a perspectival vanishing point from viewers, and of confronting them with themselves, pointed Aycock in the new direction of site-specific art presentation. Although her projects only occasionally reflect the topography of a particular location (and this differentiates her from most other Land Art artists), her works are nevertheless bound to a specific location. One cannot relocate them without destroying them. The ground in which Aycock buries her architectural sculptures and the unbounded landscape above the sculpture are just as indispensably a part of her work as are the materials wood or concrete.

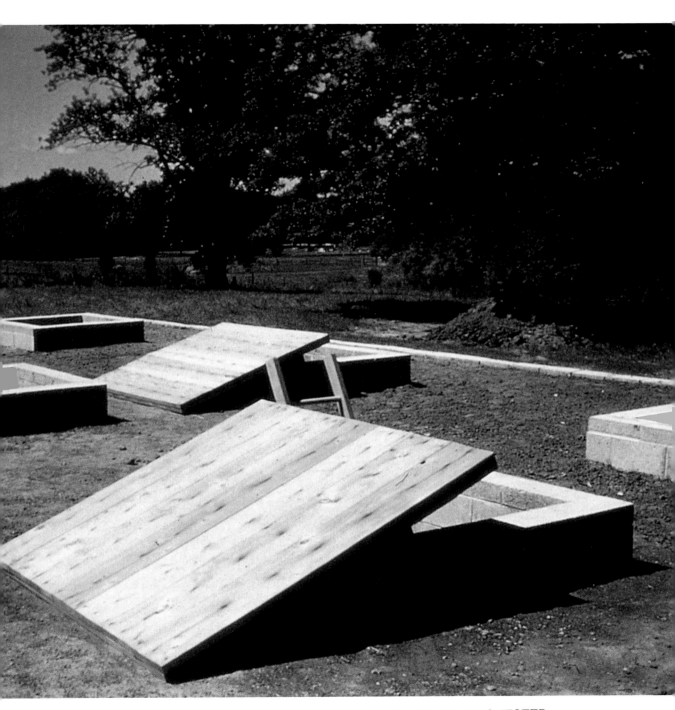

mill creek canyon Earthworks

King County, Washington; grass, earth, water, area 18,000 m^2

b. 1900 in Haag am Hausruck, Austria, d. 1985 in Santa Barbara (CA), USA

In the 1920s the Austrian Herbert Bayer first oversaw the printing and advertising workshop at the Bauhaus in Dessau, later moved to Berlin, and in 1938 had to emigrate to the USA. He was an extremely versatile commercial artist and typographer, as well as a painter, photographer and exhibition architect. He became a pioneer against his will, however, when the seminal 1968 New York exhibition *Earth Works* showed a photograph of his *Earth Mound*.

Bayer had designed the *Earth Mound* in 1955 for the grounds of the Aspen Institute for Humanistic Studies in Aspen, Colorado. It was a simple circular grass embankment with a diametre of twelve metres. Through a narrow entrance paved with flagstones, one finds three symbolic elements within its walls: a round depression, a conical hill, and a granite stone. Although Bayer became a precursor of Land Art with this installation, he distanced himself from any such description, and constantly emphasized his original connection with nature, which is foreign to later Land Art: "these rather simply designed areas merge gradually into a natural environment. artistically designed elements were added to the park as sculptural and spatial forms, meant to be enjoyed, to draw attention to the sun and the shadows and the changing of the seasons, and to use elements of nature itself as design elements."

In the following years Bayer occupied himself repeatedly with landscape-design projects, and thereby remained an outsider to Land Art. As was also the case in his numerous designs for exhibitions, he was interested in using dynamic lines and wave forms to guide viewers. In 1979 when the city of Kent announced a competition to landscape a flood plain along Mill Creek, Bayer won with his *Mill Creek Canyon Earthworks* proposal. He crisscrossed the spacious grounds with footpaths; his embankments, ring-shaped and conical hills, a pond with an inner ring of grass, and a bridge with a viewing platform, gave the green area a varied, wavy structure, which continually presented new perspectives when one wandered through it.

For the park's inauguration Bayer composed an exact description of his project, reiterating in this text his idea for harmonically combining geometry and nature: "some years ago I conceived the idea that large outdoor sculptures organic with the surroundings could be built with earth. this led to various applications for undulating landscapes and gardens, mounds and sculptures. while my previous earthworks are primarily concerned with the issues of sculpture as art alone, the mill creek earthworks have a decided purpose and function. as integral parts of the water retention basin, they control the flow of water. they are abstract forms of geometric delineation. their roundness and angles of incline are conditioned by rules of water flow and maintenance. they express a play of positive and negative three-dimensional bodies, light and shadow, surface textures, water, motion and sound, in short all the qualities of sculptural art, to make a walk through it an enjoyable experience of diverse facets of tranquillity and serenity."

"it is an experience of contrast of geometry and harmony with nature."

herbert bayer

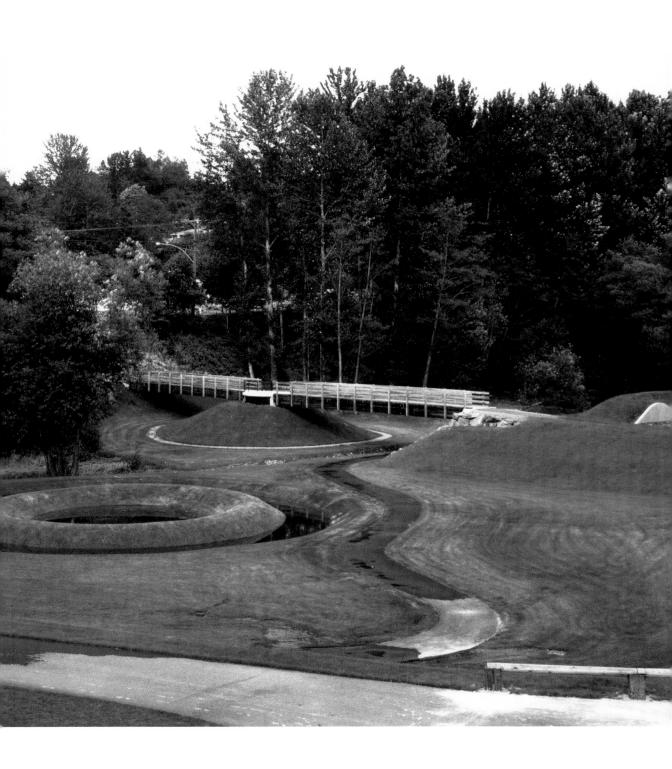

wrapped coast

Little Bay, Sydney; wrapping of a coastal region approximately 2.4 km long and from 46 to 244 m wide, with 92,900 m^2 of erosion protection fabric, 56 km polypropylene rope

Christo and Jeanne-Claude were both born on June 13th 1935

Christo has wrapped an impressive number of objects, binding them in ordinary fabric. He simply packed or wrapped everything: bottles, tins, boxes and barrels. Christo and Jeanne-Claude even wrapped entire museums and equestrian statues. Christo's earlier wraps of the 1960s gave everyday objects an ambivalent form, sometimes altering them to the point of unrecognizability. The wrappings did not follow product-design standards, but rather an improvised, hand-made aesthetic with wrinkles and knots that created the irregular contours of the surface. Christo draped fabric directly around the objects, ensured there were curves and convexities, and finally tied them with many knots.

It was in their large-scale projects beyond the walls of museums and galleries that Christo and Jeanne-Claude began to challenge the usual perceptions of urban and natural surroundings, as with 1961 *Dockside Packages* in Cologne and 1968 *5,600 Cubicmeter Package* in Kassel. Wrapped things always attract a type of attention that, unwrapped, had never been paid to them before. When the monumental proposal by Christo and Jeanne-Claude became known – to wrap a kilometre-long strip of coastline south-east of Sydney – it started an unprecedented discussion about art and nature.

Prior to their undertaking in Australia, Christo and Jeanne-Claude had received a grant from the industrialist and collector John Kaldor. Kaldor was very surprised when Christo and Jeanne-Claude did not suggest an exhibition of their objects, but submitted the *Wrapped Coast* project instead. Nevertheless, Kaldor soon became the coordinator of the daring venture. He found a suitable strip of coast in Little Bay, overcame bureaucratic obstacles, rebutted the objections of conservationists, and was able to win the support of public opinion, which was initially sceptical.

The bay selected by Christo and Jeanne-Claude lies 14.5 km from downtown Sydney. The rocky coastal region that they wrapped is approximately 2.4 kilometres long and varies from 46 to 244 metres wide. The cliffs at its north end reach a height of 26 metres, while to the south it trails off as a sandy beach.

The artists and Kaldor experimented with various synthetic woven fabrics. They selected a light and breathable fabric made of polypropylene, and commonly used as erosion-control fabric. 92,900 square metres of this fabric were ultimately used for the wrapping. 56 kilometres of polypropylene rope held the fabric to the cliffs. 15 trained mountain climbers and many helpers did the actual wrapping of the area. The job took 17,000 person hours, hindered primarily by strong wind.

These figures can only give a vague idea of the project's logistical difficulties and costs. The costs to produce, sew and transport the fabric alone exceeded the initial budget by many times. Christo and Jeanne-Claude financed the entire project by selling studies, drawings, collages and models.

From the day it opened on October 28th, 1969, the coast stayed wrapped for four weeks. Walking on the wrapping was a sensation for every visitor: The fabric reflected the sun. It was dazzling, it was soft and elastic, and close to the sea it was damp and smooth. There was a danger of stumbling and slipping on its uneven and stony surface. Observed from the centre of the wrapping, the sea, sky, wind and sun seemed oddly unreal and strange, for one was situated in a completely artificial landscape of opaque synthetic material.

> **"we picked the shoreline, because the earth starts where the sea ends. The sea gives the only real geological relief of the earth."**
>
> **Christo and Jeanne-Claude**

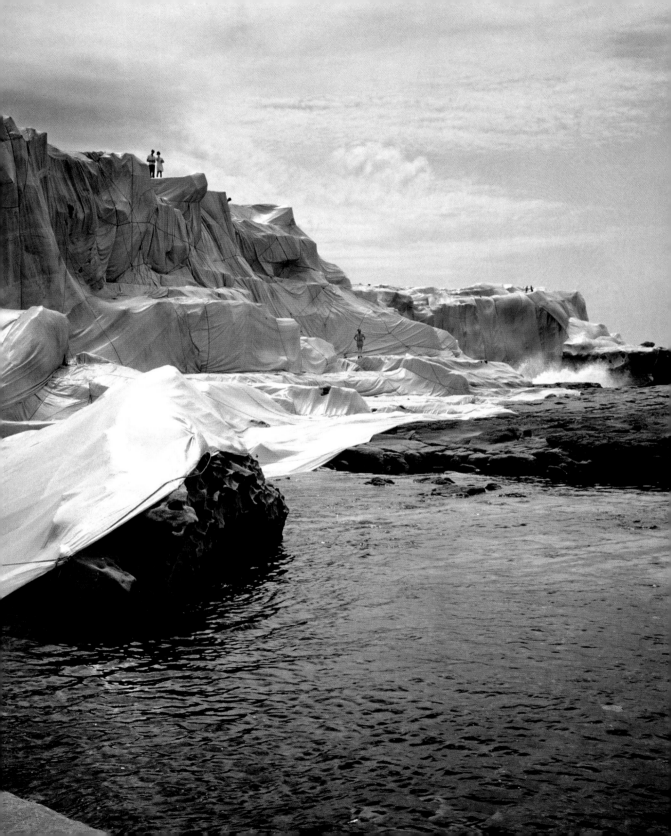

valley curtain

Grand Hogback, Rifle, Colorado; curtain made of 12,780 m^2 of orange nylon fabric, width 381 m, height 111 m on the sides and 55.50 m in the middle

In the summer of 1970, Christo and Jeanne-Claude planned a curtain in a valley. In the surroundings of Aspen, Colorado, the artists had searched for a valley across which they would be able to hang a gigantic, orange-red-coloured curtain. They chose the colour to form the most striking harmony with the surrounding countryside, because Colorado means red in Spanish. In the Grand Hogback range of the Rocky Mountains, twelve kilometres north of the town of Rifle, they finally found a mountain gap that was ideal for their plan *Valley Curtain*. The extensive logistical and technical preparations, press conferences, and permit applications began in the autumn of 1970, and contracts were signed with the private landowners, various companies, and officials. The Valley Curtain Corporation, founded expressly for this purpose, was to look after financing the costly enterprise through the sale of drawings, collages and models, but also of Christo's works of the fifties and sixties.

As in all of their large-scale projects, Christo and Jeanne-Claude initially had to overcome much resistance. They particularly had difficulties with the first engineering company they hired and with the responsible authorities – primarily with the State Highway Department, which was responsible for granting the permit to work above the highway. While the curtain was elevated in October of 1971, it unfurled prematurely and was destroyed. The project was postponed until the spring of 1972 and a new curtain was sewn.

When on August 10th, 1972 the last of 27 lines holding the curtain's 12,780 square metres of orange nylon fabric were raised, it was a perfect sensation. Art lovers, collectors, onlookers, art critics and a host of filmmakers had been waiting for this moment. Yet the next day they had to take the curtain down once more due to a storm. The curtain threatened to become a gigantic sail, capable of developing a force that could not be held. The coordinator of the enterprise, Jan van der Marck, chronicled the overwhelming spectacle: "Nobody but the artists and the engineers had quite anticipated the awesome pres-

sures on the curtain; it strained and groaned in the gentlest breeze. At twenty knots the wind load on the curtain equaled the force needed to propel two ocean liners at full speed."

Yet for Christo and Jeanne-Claude the 28 hours that the curtain obstructed the valley was by no means the fatal end to their idea. For them the 28 months of its construction counted just as much as the final day: "We had been warned by our Valley Curtain engineers that the curtain should have air holes in it, or it would stay a very short time, and it did stay little. And it will be very dangerous to build, but we should go through that to do it. And of course, this is our privilege. We are happy that the Valley Curtain was exactly as we wanted it."

Le rideau de fer, 1962

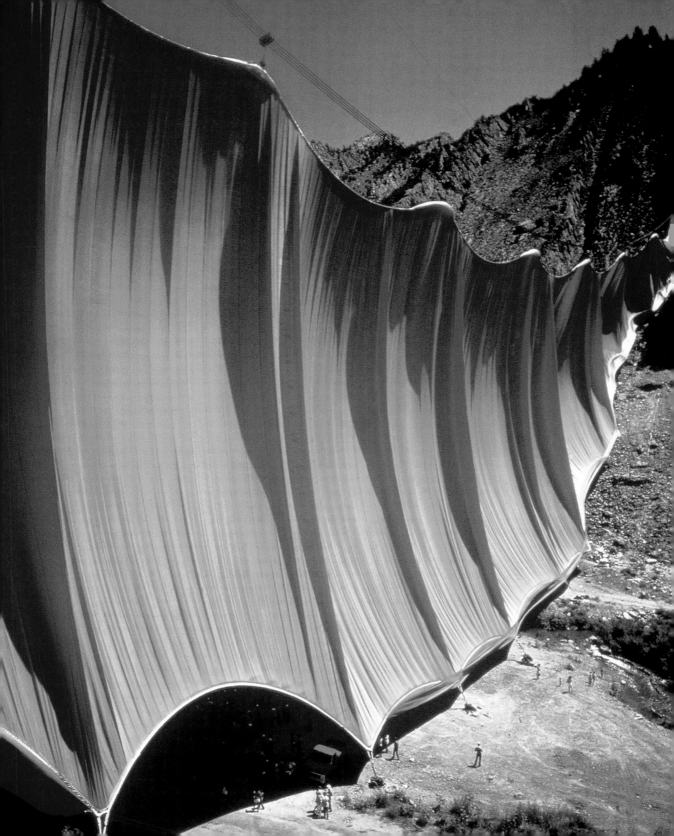

The NEW YORK Earth ROOM

New York; mound of earth, mass 200 m³, height 56 cm, surface area 335 m²
Collection of the Dia Art Foundation, New York

"The dirt (or earth) is there not only to be seen but to be thought about!"

Walter De Maria

b. 1935 in San Francisco (CA), USA

On September 28, 1968 in Munich's Heiner Friedrich Galerie, Walter De Maria opened an exhibition that was soon to become legendary. He had spread 45 cubic metres of dark black humus evenly throughout the 72 square metres of the three gallery rooms. Using the window ledges as reference, the soil was about 60 centimetres deep. A glass plate of corresponding height at the gallery entrance allowed the soil to be viewed, but prevented visitors from entering the rooms. De Maria appeared on the exhibition's programmatic poster with the expectant pointing gesture of a prophet. A floor plan and side elevation of the gallery also printed there indicated the significance of the location, which through its measurements determined the amount of "fill" necessary.

With carefully calculated pathos, the artist also pronounced his lofty aspirations on the poster. The words "Pure Dirt – Pure Earth – Pure Land" were his assertion of the absolute purity of his artistically employed materials. No objects were exhibited and there were no marks or impressions made by humans upon the dirt. De Maria thereby took leave of all expectations of common artistic methods, and from all gallery exhibitions oriented on sales figures. Nothing grew in or upon the earth, and its physical presence and formlessness made it nothing more than one of the four elements of nature (beside fire, water and air).

Thereby De Maria negated the ancient idea of the earth as the primary material of creation as Paracelsus had described it: "All corpora were born from the earth, for the earth is a mother of all corporeal things. For the first person was made from earth, and after him all people are of the earth and must also be sustained by the earth …" De Maria, however, had constructed a "pure" situation for viewers, in which nothing flourished. The Munich installation, in a gallery on noble Maximilianstrasse of all places, became a room for contemplation and meditation, and descriptions of it always vacillated between irony and emphasis. On the one hand, earth as a material (and also as a material of contemporary art) seemed to be readily accepted. On the other hand, it had been as good as banned from the environments of big-city dwellers in its unrefined state. "God has given us the earth, and we have ignored it," De Maria reminds visitors in his press release.

The Munich installation was removed at the end of the exhibition. De Maria produced two further earth rooms in other cities. His sensational first piece in Munich in 1968 was followed by a second in the Hessisches Landesmuseum in Darmstadt in 1974, and finally by a third in New York. The *New York Earth Room* of 1977 is the only earth room still in existence, maintained by the Dia Art Foundation. Its more than 100 tons of topsoil, consisting of dirt, peat and bark, has to be carefully tended. One can view it daily in the second floor of a factory building in Wooster Street, in the former artists' district of SoHo. The room, which one cannot enter and can only view from the doorway, seems quiet, still and almost sacred in the midst of the hectic, loud city. The earth seems more elemental than one ever gets to see it anywhere else.

Poster, Galerie Heiner Friedrich, Munich, 1968

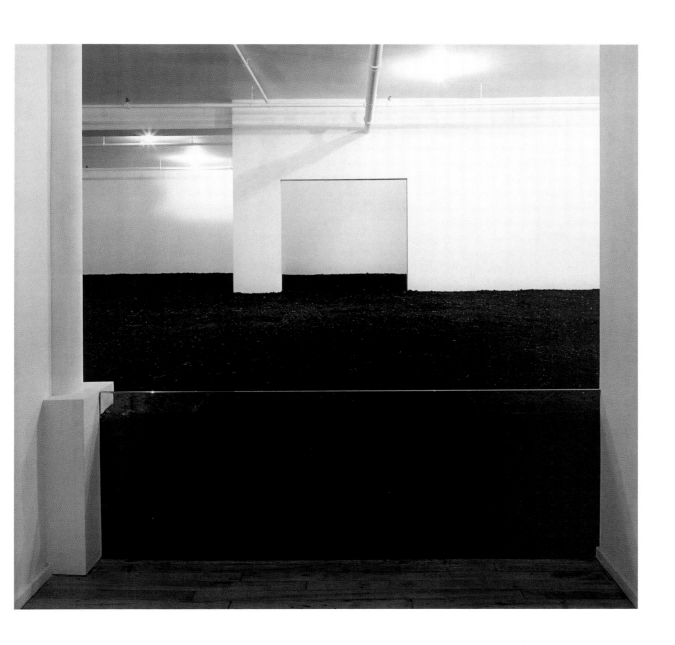

The Lightning Field

New Mexico; 400 stainless steel rods, area 1 mile x 1 km, height 6.19 m, Ø 5 cm
Dia Art Foundation, New York

When Walter De Maria showed his *Bed of Spikes* – five rectangular high-grade steel plates with sharply pointed square steel bars – in New York's Dwan Gallery, *Time* magazine celebrated him as a "High Priest of Danger". A serial aesthetic, numbering systems, and technically perfect industrial production made this 1969 exhibition a highlight of Minimal Art, even though the steel spikes presented an obviously intentional and real threat to the viewer. With a good sense for promotional effectiveness, the Dwan Gallery mailed out a release form that each invited guest had to sign, indemnifying the gallery and the artist from legal responsibility in case of an accident. It was an unconventional, almost spiritual staging of danger, perfection and beauty.

In the mid-1970s De Maria once again planned a project with stainless steel rods for a particular location, this time for an installation in the New Mexico desert. For five years he had searched the states of California, Nevada, Utah, Arizona and Texas for his ideal site that was to be level and remote, and at the same time the setting of frequent thunderstorms. After making a small prototype in 1974 in Arizona, he worked from June to October in 1977 to create the *Lightning Field* on a plateau north of Quemado, New Mexico. Within an area measuring 1 mile x 1 kilometre, he vertically embedded 400 steel bars with points on their upper ends in concrete foundations in the desert floor. The elegant, long stainless steel rods are regularly spaced at 66-metre intervals. By means of extremely accurate measurement, their upper tips all lie at the same level, and because the ground is uneven the rods are of various lengths. With an average height of 6 m, the rods catch the sun's first rays even before it can be seen above the horizon. The rods become almost invisible when the sun is high around lunchtime, and appear to continue to glow long after sundown. Yet the sublime interplay between art and nature is revealed above all during a thunderstorm, when the rods are struck by lightning.

The relationship between people and space is of vital importance to De Maria, and traversing the immense field opens up ever-new perspective arrangements, viewing angles and vanishing points. The artist has therefore planned visits with extreme care, and viewing reservations must be made by writing to the Dia Art Foundation, which commissioned and now maintains the installation. No more than six visitors may be on the property at any one time, and they must remain there for at least 24 hours (a little cabin set up specifically for this purpose serves as a shelter). Some visitors consider the restrictions to be an annoying authoritative gesture, yet it is a necessary part of the artistic concept: Only in this way can the individuals fully experience the great space.

De Maria published "Some Facts, Notes, Data, Information, Statistics and Statements" about his work in the magazine *Artforum* in 1980. Here he exhaustively provided the technical figures and calculations required to produce *Lightning Field*, in order to demonstrate the installation's perfection. The sum of all the facts, however, is not what is important to him in the work. No sequences of numbers or photographs can completely describe *Lightning Field*. It must be experienced directly on location, and the artist describes this in this manner: "Isolation is the essence of Land Art."

"The land is not the setting for the work but a part of the work."

Walter De Maria

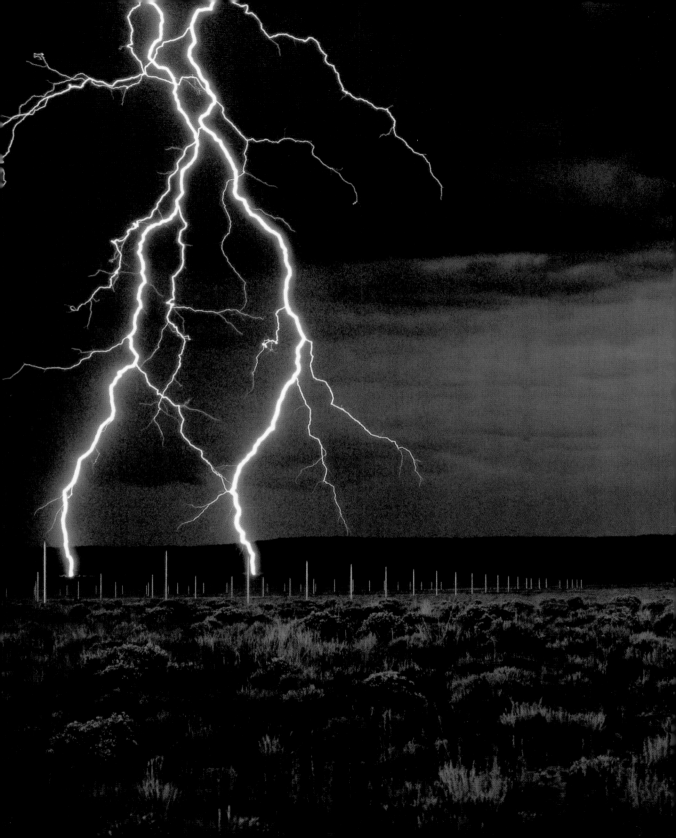

wheatfield – A confrontation

Battery Park City Landfill, New York; sown and mown wheat, area 8000 m²

b. 1931 in Budapest, Hungary

In 1982 a spectacular action by artist Agnes Denes caused a stir when she planted a wheat field on the edge of one of the most densely developed cities in the world. At the beginning of the 1980s, the rubble excavated during construction of the World Trade Center was dumped into the Hudson River at the southern tip of Manhattan to create a building site for Battery Park City and the World Financial Center. For a while the landfill was the largest empty lot in Manhattan, where Denes and artists such as Alice Aycock and Mary Miss were able to carry out temporary sculpture projects.

Denes had 80 truckloads of topsoil spread on almost 8000 square metres of this area, which was actually unsuitable for agricultural use due to the urban waste and scrap that had also been dumped there. She manually dug 285 furrows, moved rubble and waste aside, and sowed the wheat by hand. Thanks to care, irrigation and fertilization the grain grew in the following months, much to the enthusiasm of many onlookers. It was finally mown at harvest time, but because of the contamination of the soil it could not be used further.

For Denes the bright, flat wheat field formed a symbolic contrast to the city's grey skyscrapers. The wheat field's yellow hues contrasted effectively with the two dark towers of the World Trade Center, and on the horizon over the heads of grain, one could see the Statue of Liberty like a hopeful promise. Additionally, the field was located in the immediate neighbourhood of Wall Street, where world trade determines the prices for food.

The contrast Denes was seeking was not without a certain agricultural romanticism: a longing for country living tied into the natural cycle of the seasons. Not only did she demonstrate the estrangement of city-dwellers from agricultural production, however, but also the economic and political interests in the grain trade. "Manhattan is the richest, most professional, most congested, and, without a doubt, the most fascinating island in the world," declared the artist. "To attempt to plant, sustain, and harvest two acres of wheat here, wasting valuable precious real estate, obstructing the machinery by going against the system, was an effrontery that made it the powerful paradox I had sought for."

For Denes the wheat field was an expression of elemental contexts. Wheat is an important part of the national self-image of the USA; the "breadbasket of the world" with its nearly endless grain fields is a frequent motif in American painting. Reactions to the field were thus all the more controversial. *Time* magazine entitled its report about the action "Amber Waves of Grime", a parody of the line "Amber Waves of Grain" from a patriotic song. The indignation was politically motivated. At the time of the action, American farming was stuck in the greatest grain-market crisis since the 1930s, and President Jimmy Carter imposed a grain embargo against the USSR. The grain field, as Denes wrote, "… referred to mismanagement and world hunger. It was an intrusion into the citadel, a confrontation of High Civilization. Then again, it was also Shangri-la, a small paradise, one's childhood, a hot summer afternoon in the country, peace."

"'wheatfield' was a symbol, a universal concept. ıt represented food, energy, commerce, world trade, economics."

Agnes Denes

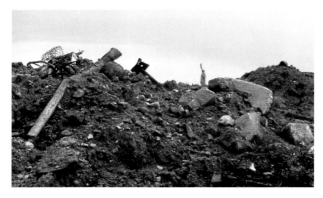

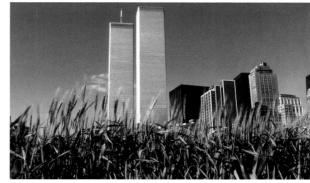

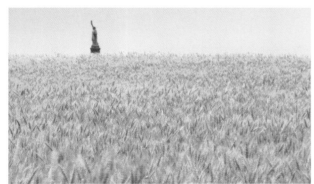

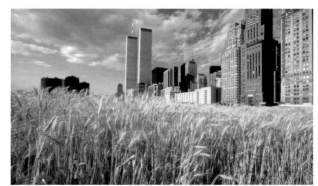

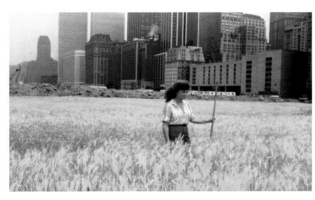

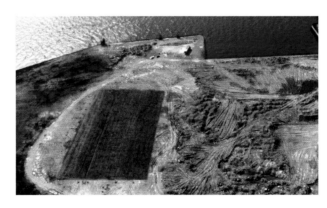

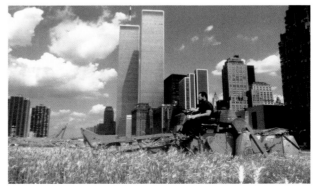

Land/sea

360 colour slides, parallel projection by six slide projectors

"A photograph does not produce an image. It registers gradations of light."

Jan Dibbets

b. 1941 in Weert, Netherlands

Perception is central to Jan Dibbet's artistic strategy, and he examines it primarily through the equipment-contingent limitations of photography. Following the tradition of Dutch landscape painting he photographs the calm sea, the flat coast, and the complex structures of streams and mounds of leaves.

Due to its wide use, photography often seems to possess no materially tangible surface. Its motifs come to the fore to such an extent that one forgets they are constructed images. Dibbets cuts up the photographic material, however, gluing it to paper and remounting it with schematic drawings to suit photography's requirement for perspectival construction. It is a graphic montage of the experience of time and space pictorially communicated − but also conditioned − by the medium of photography.

Another method Dibbets uses to return materiality to photography is the photographic series: shots of rooms taken at set time intervals or with ever-shorter shutter speeds, whereby Dibbets demonstrates the (chemical) effects of lighting on the photographs' brightness.

For his installation *Land/Sea*, which Dibbets exhibited at the 1972 Venice Biennale, he hung six slide projectors from the ceiling of the room, projecting 60 slides from each projector onto two adjacent walls. A long horizon line seemed to connect the projected images. On the left side were three shots of the green coastal landscape upon which only grass grew, and on the right were three shots of breaking sea waves. In the programmed sequence of projections the horizon line shifted up and down to the accompaniment of the whirring of the equipment and the clicking of the slide carousels. It was a simple visual trick: Dibbets used the slide several times, doubling and tripling the same image.

Besides the vanishing point, the horizon is the most important coordinate for perspective drawing. Dibbets uses no vanishing point in his staged arrangements, and through displacement he parodies the traditional use of a low horizon line, as seen for example in the paintings of the German Romantic Caspar David Friedrich. The strange image quality of the slide projections and the projectors' rhythm and noise transform the seemingly familiar shots of the coastal landscape into an abstract composition, which calls to mind the subtle lines and planes of the Dutch abstractionist Piet Mondrian.

Dibbets has repeatedly used experimental forms of photography, providing them as an indicator of what a photographer actually saw. Together with New York gallerist Seth Siegelaub he organized a truly astounding exhibition: He sent a postcard, on the front of which were two photos: a building facade with one balcony marked, and a self-portrait with an ironically playful 'thumbs up' gesture of measuring and arranging. The back of the card announced the exhibition: "On May 9 (friday), May 12 (monday) and May 30 (friday) 1969 at 3:00 Greenwich Mean Time […] Jan Dibbets will make the gesture indicated on the overside at the place marked 'X' in Amsterdam, Holland."

Postcard, 1969

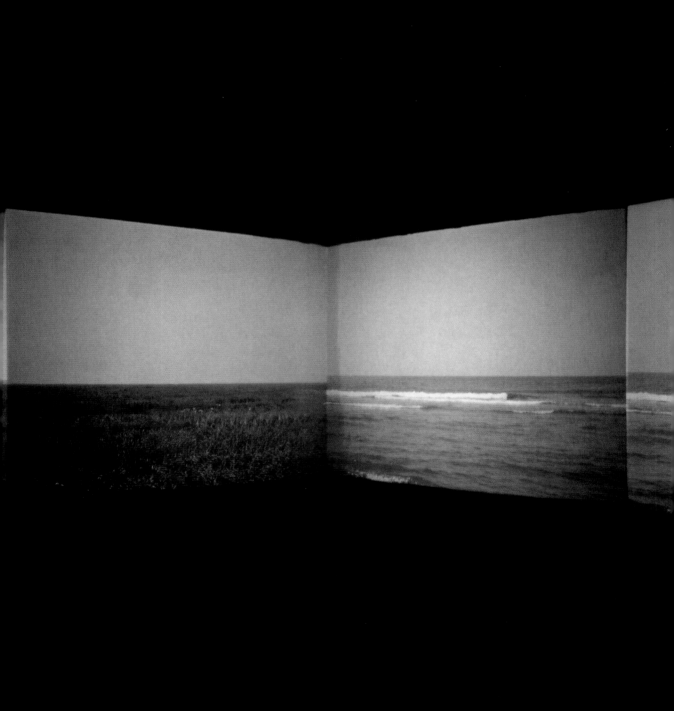

the Pilgrims' way 1971

Photography and text on cardboard, variable dimensions
Collection of Hamish Fulton

b. 1946 in London, England

In the following statement, Hamish Fulton outlined the content and boundaries of his artistic work, which revolves exclusively around the experience of his walks: "My work is about the experience of walking. The framed artwork is about a state of mind – it cannot convey the experience of the walk. A walk has a life of its own, it does not need to be made into art. I am an artist and choose to make my artworks from real life experience."

As a "walking artist", Fulton neither intrudes on nature, nor does he photographically document the regions in which he hikes. He prefers traversing isolated, deserted areas, such as along Kent's Pilgrims' Way or Peru's Nazca Lines, down streets and paths in Scotland, into the South Dakota Badlands, and in the high mountain areas of Tibet and Nepal. For him walking is not just a means of achieving self-awareness: walking itself is his art, and it forms the constant in his work.

Fulton's photographs of the landscape are strangely inapproachable. His motif selection, which invokes a feeling for the area's inhospitality in viewers, contains few narrative moments. For example, Fulton photographed himself in a landscape, holding a flashlight pointing into the camera. Without commentary, he has hung two shots next to each another showing exactly the same location, but taken at different times or in different types of weather during his hikes. He has repeatedly photographed deserted streets and paths leading, with no vanishing point, into the distance.

"The artwork cannot represent the experience of a walk," explained Fulton. "The flow of influences should be from nature to me, not from me to nature. I do not directly rearrange, remove, sell and not return, dig into, wrap, or cut up with loud machinery any elements of the natural environment. All my artworks are made from commercially available materials (wooden frames and photographic chemicals). I do not use found-natural-objects like animal bones and river stones. However, the difference between these two ways is symbolic, not ecological."

Fulton also used simple means to illustrate his ten-day walk in April 1971 along the almost 200-kilometres of Pilgrims' Way from Winchester Cathedral to Canterbury Cathedral. For *The Pilgrims' Way 1971* he used a shot of a low-lying woodland path overshadowed by imposing trees, roots and bushes. Fulton contrasts the photograph of this centuries-old path that is evocative of the Romantic era – the epitome of such paths, as it were – with information about the course of the hike. He mounted both the photograph and the text panel with its simple typeface in a simple brown wooden frame on a white piece of cardboard. Beneath this photograph and textual data in his artist's book *Hollow Lane*, Fulton quotes a further four lines from the late medieval verses of *Canterbury Tales* by Geoffrey Chaucer, in which every person is described as a pilgrim.

The form of the confrontation between photography and text is thus dependent on its media context. However, it always delineates the inequivalence of text and image in view of the physical and spiritual experience of the walk. These are – to use an expression by the artist Martha Rosler – two "inadequate descriptive systems".

The Distance, 1997

The Pilgrims' Way

1971

A HOLLOW LANE ON THE NORTH DOWNS – ANCIENT PATHS FORMING A ROUTE BETWEEN WINCHESTER AND CANTERBURY TEN DAYS IN APRIL – A 165 MILE WALK

A 21 Day coast to coast walking Journey ... Japan 1996

Installation in the John Weber Gallery, New York; oil and vinyl paint on wall, variable dimensions

Since the 1980s Hamish Fulton has been showing works that he paints directly on exhibition-room walls. Fulton plans and designs his texts on paper. He annotates the designs with precise details about font, size and colour, and about the spaces between words on the wall. Executing the piece is then left to craftspeople who remain anonymous. Fulton intentionally never uses the pronoun "I", and his wall pieces are as impersonal in terms of typography and choice of words as is the information on a boundary stone in the landscape.

In 1996 after a walk on the Japanese peninsula of Kii Fulton presented, in the John Weber Gallery in New York, a wall piece consisting solely of words. Five single words were repeated several times: "sky", "cloud", "tree", "raven" and "sea". The vertical and horizontal rows made up by these five words enclosed several lines of text listing the dates and route of the walk: *A 21 DAY COAST TO COAST WALKING JOURNEY ON ROADS AND PATHS STARTING ON THE FIRST DAY OF MAY FROM THE MOUTH OF THE KAMENO RIVER IN WAKAYAMA ENDING AT THE MOUTH OF THE MIYA RIVER IN ISE TRAVELLING BY WAY OF SHIONOMISAKI KUMANOHONGU SHAKAGATAKE OMINE MIWASAN MOUNT HIEI MIUNE YAMA KII PENINSULA JAPAN 1996.*

This information about the walk is so sparse that it only provides an approximate idea of the distance travelled, the cultural outlandishness, and the character of the terrain in the region (particularly in contrast to New York, the exhibition's location). No mention is made of the many worthwhile sights or shrines that the Japanese peninsula Kii is famous for among tourists.

In the New York installation, the text is painted in shades of grey and black. The five words, laid out in rows and plateaus, enclose the body text in the middle of the wall and produce abstract patterns from their contours. One could draw a line, like a horizon, above the lower horizontal row formed by the word "sea". The word "sky" borders the entire upper, mirror-symmetrical field of words, and the words "cloud" and "raven" have been inserted within the field. The word "tree" snakes through the text, creating an outline that one could view as a schematic contour of a mountain or hill.

On the other hand, the line breaks and typography are reminiscent of the design of signs in Fulton's photo-text works, with the essential difference being that he no longer uses photography in this work. The five individual words in this inappropriate location therefore take on symbolic meaning that, however, every viewer can interpret differently. "The texts are facts for the walker and fiction for everyone else. Walking into the distance beyond imagination." Fulton makes clear that the various visual experiences and physical effort of a walk cannot be reproduced. Viewers should therefore consider the words on the wall to be only a trace of the walk. Their bleak, dull surface in shades of grey and black shifts the act of reading into the realm of symbols, and serves as a starting point for "a type of visual oscillation – similar perhaps to that loss of meaning that Zen terms Satori" (Roland Barthes).

"The artwork cannot represent the experience of a walk."

Hamish Fulton

SKY SKY SKY SKY SKY SKY SKY SKY SKY SKY SKY SKY SKY SKY

SKY SKY SKY SKY SKY SKY SKY CLOUD SKY SKY SKY SKY SKY SKY SKY

SKY SKY SKY SKY CLOUD CLOUD TREE CLOUD CLOUD SKY SKY SKY SKY

SKY SKY SKY SKY SKY CLOUD TREE TREE CLOUD SKY SKY SKY SKY SKY

SKY SKY SKY SKY SKY SKY TREE TREE TREE TREE SKY SKY SKY SKY SKY SKY

SKY SKY SKY SKY SKY TREE TREE TREE TREE TREE SKY SKY SKY SKY SKY

SKY SKY RAVEN SKY TREE TREE TREE TREE TREE SKY RAVEN SKY SKY

SKY SKY SKY SKY TREE TREE TREE TREE TREE TREE SKY SKY SKY SKY

SKY SKY SKY TREE TREE TREE TREE TREE TREE TREE SKY SKY SKY

SKY SKY SKY A 21 DAY COAST TO COAST WALKING JOURNEY SKY SKY SKY

SKY SKY SKY TREE TREE ON ROADS AND PATHS TREE TREE SKY SKY SKY

SKY SKY SKY TREE STARTING ON THE FIRST DAY OF MAY TREE SKY SKY SKY

SKY SKY FROM THE MOUTH OF THE KAMENO RIVER IN WAKAYAMA SKY SKY

SKY SKY TREE ENDING AT THE MOUTH OF THE MIYA RIVER IN ISE TREE SKY SKY

SKY SKY TRAVELLING BY WAY OF SHIONOMISAKI KUMANOHONGU SKY SKY

SKY SHAKAGATAKE OMINE MIWASAN MOUNT HIEI MIUNE YAMA SKY

TREE TREE TREE TREE KII PENINSULAR JAPAN 1996 TREE TREE TREE TREE

SEA SEA SEA SEA SEA SEA SEA SEA SEA SEA SEA SEA SEA SEA SEA SEA

тhin ice / made over two days / welded with water from dripping ice / hollow inside

Scaur Water, Penpont, Dumfriesshire, Scotland; photograph, 76 x 76 cm

b. 1956 in Cheshire, England

For Andy Goldsworthy "nature" is no longer just a concept: "My art makes me see again what is there, and in this respect I am also rediscovering the child within me. In the past I have felt uncomfortable when my work has been associated with children because of the implication that what I do is merely play. Since having children of my own, however, and seeing the intensity with which they discover through play, I have to acknowledge this in my work as well." He belongs to a younger generation of artists still characterized as belonging to the Land Art movement, but who did not participate in the historic exhibitions at the end of the 1960s.

Like the proverbial child, Goldsworthy is interested in the nature of things, in their colour, form, and composition, in their taste and smell, and in their place within nature. He prefers locations where people live and work; places like Penpont in Scotland, which has been his home for a long time now. Here he works through changes in the weather and the rhythm of the seasons. He uses the colours of leaves, or icicles that he forms into star-shaped or snakelike sculptures that last only a short time before melting. To express his travels through nature he uses nests made of driftwood, skittles made of stone, lines made from leaves that floated downstream, circles of wilted fern stems, lines of coloured leaves in the grass, sticks thrown into the air, and little powdery balls of iron oxide or snow.

In a race against time, Goldsworthy seeks the volatile instant of balance in which a fragile, evanescent work steps from one dimension into another. From his point of view this is a moment of "energy". Only with his Hasselblad camera does he manage to capture this reversal. When he is working, as he explained in an interview, his detachment from the sculpture is not great enough, because he wants to be directly in contact with things. He thus views photography as his language for describing his art, and in which he sees and recognizes what he does. Photography is the only medium he uses to documents his performative work.

His choice of materials mirrors the diversity of nature: water, ice, snow, sand, stones, sticks, thorns, stalks, leaves, flowers, berries and bird feathers. He generally uses natural materials to makes changes, splitting heron feathers with a sharp stone, for example, or using thorns to fasten down leaves. His artistic mien is the common thread running through his work: Goldsworthy continues the themes of existing contours, taking them just so much farther that they acquire a new, ornamental natural form. Thus brown leaves may become a snail shell sitting in a tree fork, or icicles are combined into the radiant structure of a star, like with *Thin ice / made over two days / welded with water from dripping ice / hollow inside*.

It is thinking in visual harmony; his goal in playing with the surface of things is to recognize their visible and invisible natures. The fragile affiliation between tree, leaf and snail, which the next gust of wind or rain could end, and the sun's brief reflection in the star-shaped icicles of frozen water, betrays something of nature and its order. Pursuing the beauty of natural forms through a system of resemblances is an artistic competition with nature. "I had to forget my idea of nature and learn again that stone is hard and in so doing found that it is also soft. I tore leaves, broke stones, cut feathers … in order to go beyond appearances and touch something of the essence."

> **"рhotography has become the way ı talk about my sculpture."**
> **Andy Goldsworthy**

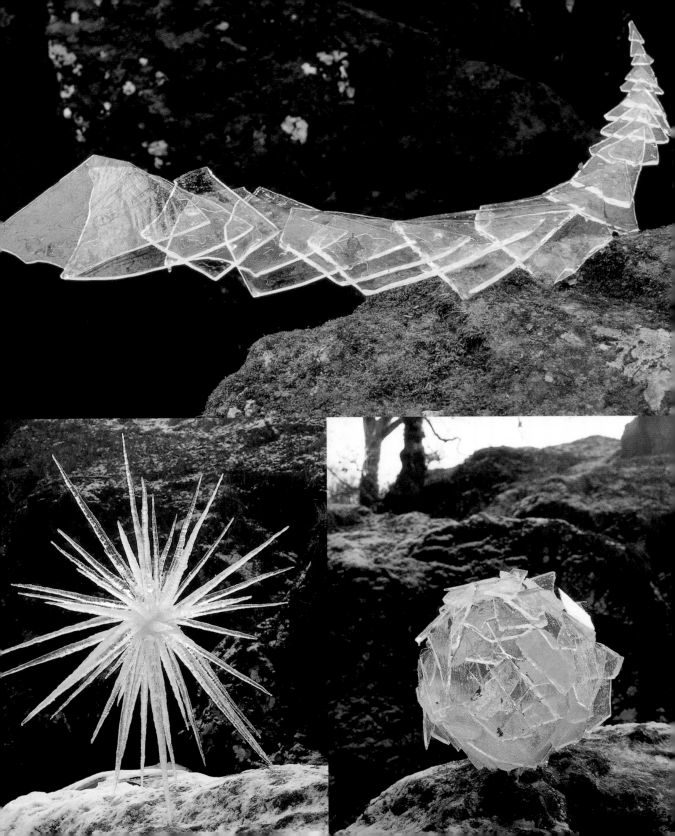

storm king wall

Fieldstone, area 1.5 x 700 m
Storm King Art Center, Mountainville, New York

The Storm King Art Center in Mountainville, New York, is a rambling and scenically beautiful park containing a large number of sculptures designed for this particular setting. American businessmen Ralph E. Ogden and H. Peter Stern founded the sculpture centre in the year 1960. On its 200 hectares of land with meadows, fields and forests set against the spectacular panorama of the Hudson Highlands, one can find many large-format pieces commissioned specifically for this location, including works by artists such as Alexander Calder, Mark di Suvero, Henry Moore, Isamu Noguchi and Louise Nevelson.

In 1997 Andy Goldsworthy was requested to create a sculpture here, and in the following two years he built the 700 m long *Storm King Wall* out of fieldstone. This project began with extensive reconnaissance of and walks around the property, where Goldsworthy discovered the dilapidated remains of old walls. In drawings, he developed the idea of using the existing structure by rebuilding the walls with the old stones, and of using them to produce a connection between the trees that had grown upon the wall's remains. The first section of the wall swings in and out between the trees in an elegant snaking line, along the same path that the old country wall once took along the close-lying river. The wall seems to dive into the river, for it gradually sinks below the water's surface, reappearing again on the opposite bank. On this side of the river the wall climbs the hill, crosses a path and finally, beyond several meadows, reaches a noisy and well-travelled highway, where it ends. The second part of the sculpture corresponds to the path of the wall as drawn on historical maps, but of which no remains have been preserved.

Although Goldsworthy generally builds his own sculptures – with half-frozen hands pushing sticks through bitten-out holes, for example, or connecting icicles – he used professional craftsmen to build the wall at the Storm King Art Center. Because of this, the wall looks like any other boundary wall built in this tradition for centuries and familiar to us, for example, from Scotland. His task, Goldsworthy declared in an interview, was to find the line of the wall and to work the space. The wall's gentle undulation truly confers a hint of movement reminiscent of flowing water. As the seasons change, the leaves' yellow and brown colours also alter the view of the wall. In winter it is covered by snow, and frozen in the river.

"The wall is a line that is in sympathy with the place through which it travels." In his poetic description, Goldsworthy plays upon a form of similarity to which the French philosopher Michel Foucault ascribed a leading role in the thinking of our Western culture. Sympathy "calls forth the movements of things in the world, and causes the convergence of the most remote things. It is the origin of mobility, drawing heavy things towards the heaviness of the earth, and light things towards the weightless ether. It drives roots towards water, and allows sunflowers to follow the path of the sun." Goldsworthy searches, within this cognitive system almost forgotten today, for the natural characteristics of things and their relationship to their location. The *Storm King Wall* runs in an undulating line through a place where topography, vegetation and history motivate its movement in many ways, and harmonize with it.

"The work is the place."

Andy Goldsworthy

Displaced/Replaced Mass

Silver Springs, Nevada; 30, 52 and 70 ton granite boulders in concrete-lined pits

b. 1944 in Berkeley (CA), USA

In 1969, without an audience and far from the art metropolis of New York, Michael Heizer directed an action he had planned that was of hardly imaginable dimensions for art before that time. In the high, snow-covered Sierra Nevada Mountains, machines lifted three massive stone boulders weighing 30, 52 and 70 tons respectively, which heavy-load transporters then hauled down from their initial altitude of 1300 metres to the bordering Nevada desert approximately 100 kilometres away. There, close to the little town of Silver Springs in the arid, sandy region of Nevada's Great Basin Desert, the extremely heavy boulders were trimmed into shape and lowered into cement-lined pits.

Little trace now remains of the daring balancing act between the archaic, ritual procession and the modern technical and logistical feat performed by the machines of heavy industry, except for photographs of the relocated boulders and drawings by the artist with precise indications of size, weight and distance travelled.

The art action *Displaced/Replaced Mass*, which took place across climactic and topographical zones from high mountains to desert, was only possible because Heizer was able to attract the collector Robert C. Scull as a sponsor. Scull had made his fortune as the owner of a taxi company. Together with his wife Ethel, in an extremely short time, he had assembled one of the world's largest collections of Pop Art. To Heizer and gallerist Richard Bellamy the collector revealed himself an ambitious sponsor desirable of cultural prestige, and excited by the artist's unusual ideas that disregarded all art-world conventions.

Heizer saw himself as an artist working independently of art market mechanisms. In an article in the magazine *Artforum*, he used the example of *Displaced/Replaced Mass* to illustrate his attitude towards the art world: "The position of art as malleable barter-exchange item falters as the cumulative economic structure gluts. The museums and collections are stuffed, the floors are sagging, but the real space still exists." The land for *Displaced/Replaced Mass* was leased indefinitely with an option to purchase, but no more than this could be acquired: "What is sold here is land, not art." Heizer vehemently criticized the societal conditions placed on art, which bow to functional, prestigious and decorative requirements. The institutions of art mediation are not least responsible for this.

Yet the documentation, drawings and photographs of *Displaced/Replaced Mass* also sold well. Notwithstanding the fact that Heizer informed the collector Scull beforehand that he would never gain physical possession of the work, and in the best case would profit from an increase in the price of the real estate, financing this project lent the collector a certain "radical chic" (Tom Wolfe). In 1971 Allan Kaprow, the inventor of Happenings, was forced to resignedly state that all artworks – and *Displaced/Replaced Mass* was no exception to this – would sooner or later be taken over by the cultural institutions against which they were directed: "Anti-art in 1969 is embraced in every case as pro-art, and therefore, from the standpoint of one of its chief functions, it is nullified."

"one of the implications of Earth Art might be to remove completely the commodity-status of a work of art."

Michael Heizer

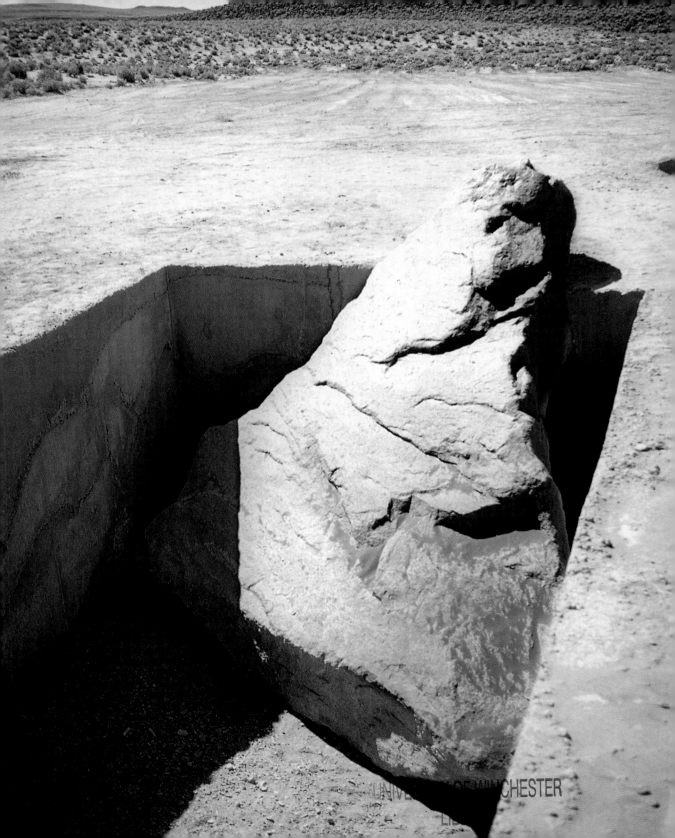

Double Negative

Mormon Mesa, Overton, Nevada; 244,800 tons of sandstone and rhyolite excavated and relocated, 450 x 15 x 9 m
Museum of Contemporary Art, Los Angeles, California

One of the icons of American Earth Art is undoubtedly *Double Negative*. Michael Heizer began this spectacular earth sculpture in December of 1969, and expended considerable technical and logistical means to have it blasted directly out of a mesa. The sculpture is located approximately 130 kilometres north-east of Las Vegas in the almost unspoilt arid land of the Mormon Mesa. All visitors tell of the sculpture's overwhelming impact, and emphasize its contrast with the hectic gambler's paradise. Gallerist Virginia Dwan, who made the project financially possible, also compared the sculpture with the distant, quiet, and seemingly infinite space of a cathedral.

Double Negative consists of two trenches separated by a canyon, but lined up with one another. The two trenches are 230 and 100 metres long respectively, and are both nine metres wide and 15 metres deep. To give some idea of the sculpture's dimensions, the artist compared it to the approximately 450-metre tall Empire State Building in New York: a sort of urban anti-type. The two trenches were created by blasting out 244,800 tons of rock, which was then pushed downhill by bulldozers.

The two rectangular negative forms with the abyss lying between them can only be seen in their entirety from the air. Visitors, however, must experience the sculpture step by step. By descending steep ramps at the ends of the trenches, they can enter a long, narrow lane that reveals a view across the ravine to the trench on the opposite side. The dimensions are so enormous that visitors can lose all orientation between the walls, and sometimes find it initially impossible to pinpoint their location within the sculpture. Heizer therefore stipulates that you should spend at least one whole day dealing with the sculpture, in order to understand it. By this, he means to learn what the sculpture is, to grasp its size, surfaces, spatial structure, and transformations in light and shadow.

Today the formerly smooth edges of *Double Negative* are furrowed and washed out. In some places, the trench's collapsing sides have largely buried the ramps under rubble, so that the view of the sharp edges and geometrical structure of the recess is now obscured.

Heizer planned no conservation measures, however, because he wanted to make the natural geological processes of erosion visible. It is therefore only a question of time until the sculpture becomes an (allegorically construable) ruin.

Considerably smaller excavations carried out by Heizer in 1968, such as the *Nine Nevada Depressions* in Nevada's Massacre Dry Lake, disappeared under the desert sands again shortly after their creation. It is in drawings for this project that one can most clearly see Heizer's repertoire of forms, in which he combined the expressive gesture of the drawn line with his interest in geometric volumes and spatial scale. All commentators have located *Double Negative* within the tradition of American Abstract Expressionism and Minimal Art. In 1970, the German art critic Carlo Huber went a step further when he summarized his experience with the sculpture by expressing his perception that Heizer "does not work according to plan and scheme, but proceeds intuitively, no differently than painters and sculptors have done for centuries before him." Thereby he almost seems to forget, however, that for *Double Negative* Heizer had used the earth's surface as his sculptural material on a scale never before seen.

> "I guess I'd like to see art become more of a religion."
>
> **Michael Heizer**

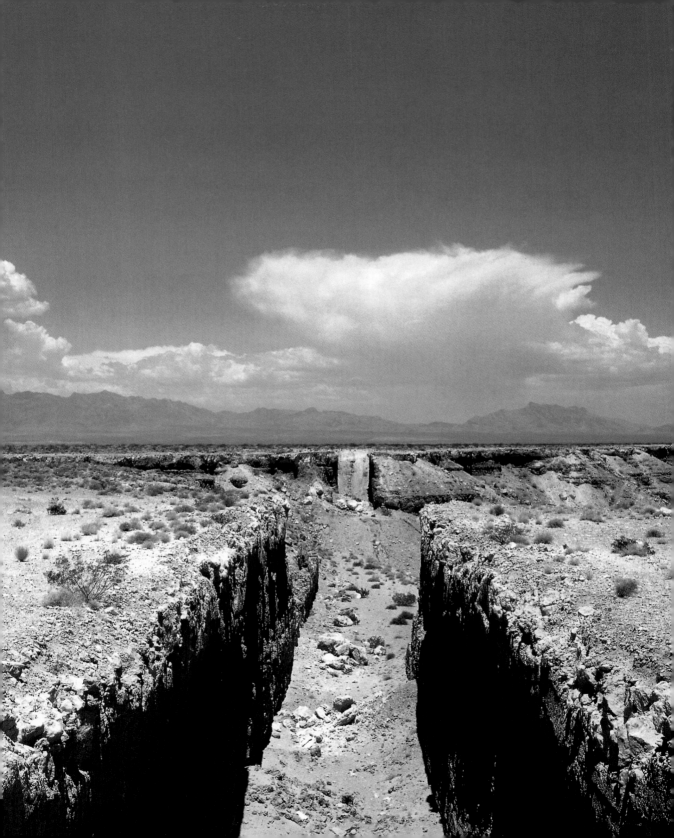

Effigy Tumuli

Buffalo Rocks, Illinois; 5 earth mounds in animal forms: catfish ca. 6 x 263 x 96 m, snake ca. 3.50 x 706 x 30 m, frog ca. 5.50 x 116 x 126 m, turtle ca. 5 x 222 x 119 m, water strider ca. 5 x 234 x 230 m
Collection of Buffalo Rock State Park, Buffalo, Illinois

Five large-scale earth sculptures by Michael Heizer, the *Effigy Tumuli*, lie on Buffalo Rock, a promontory approximately 30 metres high that stretches about 1.5 kilometres along the Illinois River near Ottawa, Illinois. Coal had been extracted from open-pit mines there in the 1930s. This had fundamentally changed the landscape, and poisonous, acidic substances in the area made the ground inhospitable to flora and fauna. After open-pit mining had ceased, the area lay fallow and was left to its own fate. In 1977, a federal law provided funds for recultivating regions affected by open-pit mining. On the initiative of Edmund B. Thornton, an advisory staff member of the Abandoned Mined Lands Reclamation Council, the state authority responsible in Illinois, the council considered the possibility of commissioning an artist. They intended the recultivation and artistic landscaping to transform the disused landscape into a public park. In an indirect process (Isamo Noguchi declined the commission) they decided to commission Heizer to produce the design.

Right from the beginning, Heizer oriented his work on figurative Indian graves and ceremonial mounds. Although he initially considered images of insects, the sculptural and abstract bodily forms of which he had admired throughout his life, he finally decided upon animals native to Buffalo Rock. After taking the measures necessary for recultivation, which included neutralizing the acidic earth with lime, he had his chosen animal forms – a water strider, a frog, a turtle, a catfish and a snake – constructed on the mounds of earth that already existed. Heizer prepared the ultimately approved designs so precisely using photography and topographic maps, that there were hardly any deviations from the figurative designs despite the huge scale involved.

There was neither a visual nor a spatial boundary between the landscape and the earth sculptures. Thereby the artist's concept clearly differed from the traditional model of sculpture parks that contained objects like abstract metal sculptures. He created a landscape park in which the five monumental earth mounds, pieced together from prismatic forms, became an integral part of the landscape. The figurative animal images could only be recognized from the air or with the aid of photographs, but not by visitors (at least not at first glance). Visitors had to envision them in their imagination while crossing the landscape, hill by hill.

The design and the ecological task of recultivation equally reflect the artist's special interest in space, mass and volume, and his interest in direct contact with the earth. After the earth sculptures were finished in October of 1985 and opened to the public in the fall of 1986, however, a slow process of erosion began. The task of conservation and maintenance should have fallen to the responsible authorities in Illinois. Today the sculptures have deteriorated to the point of unrecognizability, once again calling into question the hope for a successful and sustainable cooperation between artists, industry and state authorities.

"I'm mainly concerned with physical properties, with density, volume, mass and space."

Michael Heizer

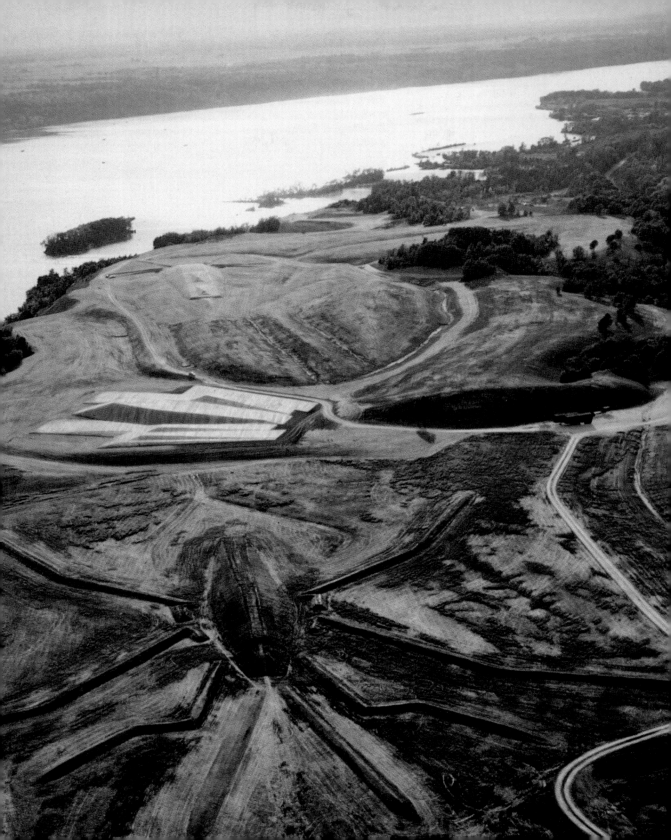

sun tunnels

Great Basin Desert, Utah; 4 concrete tubes with drilled holes, Ø exterior 2.80 m, Ø interior 2.50 m, length 5.50 m, weight 22 tons
Collection of Nancy Holt

b. 1938 in Worcester (MA), USA

It took Nancy Holt from 1973 to 1976 to install her *Sun Tunnels* deep in the Great Basin Desert in north-west Utah. After a long search, she found a suitable location for her plan and acquired a 16-hectare parcel of land in 1974. There she laid the four concrete tubes, each of which was almost six metres long, almost three metres in diametre, and many tons in weight, in two lines to form an open x shape. The *Sun Tunnels* are axially oriented on the sun's farthest position above the horizon during the summer and winter solstices. During these periods, the weeks around June 21st and December 21st, sunshine almost fills the tubes. Drilled holes of different sizes embellish each of the four concrete elements, their patterns corresponding to scale representations of four constellations: Draco, Perseus, Columba and Capricornus. During the day, the sun shines through these drilled holes and projects a wandering pattern of circles and ellipses on the bottom of the tubes.

The concrete tubes concentrate the view of the landscape and the light, sharpening one's perception of the seemingly boundless desert panorama. "I wanted to bring the vast space of the desert back to human scale," Holt said in describing her project to the magazine *Artforum.* "I had no desire to make a megalithic monument. The panoramic view of the landscape is too overwhelming to take in without visual reference points. The view blurs out rather than sharpens. Through the tunnels, parts of the landscape are framed and come into focus." Entering the concrete tubes limits your view still further, and you find yourself in the play of light and shadows created by the constellations – a means of human "orientation" since antiquity.

It took Holt four years to finish her work on *Sun Tunnels*. During this time in Utah, as she herself listed in detail, she worked with an astrophysicist, astronomers, engineers, surveyors, and a carpenter; with a company that produced concrete tubes; with core drilling specialists; with drivers of levelling machines, dump trucks, excavators, concrete-mixers, delivery trucks and cranes; with cameramen, sound engineers, the pilot of a helicopter, and the employees of a photo lab. Just the industrial fabrication, the specialization of tasks, and the painstakingly prepared installation of *Sun Tunnels* make it clear that the tubes differ from all other forms of presentation in the art world.

Despite their industrial production, the *Sun Tunnels* do not seem out of place because both their colour and their material – concrete being a hardened mixture of sand and cement – fit into the desert landscape. The artist views the work as inseparable from the site, because her own experiences of time and space in the desert, and of the specific local topographic contours, formed the piece down to the last detail. "The idea for *Sun Tunnels* became clear to me while I was in the desert watching the sun rising and setting, keeping the time on the earth. *Sun Tunnels* can exist only in that particular place – the work evolved out of its site. Words and photographs of the work are memory traces, not art. At best, they are inducements for people to go and see the actual work."

> **"I wanted to bring the vast space of the desert back to human scale."**
> Nancy Holt

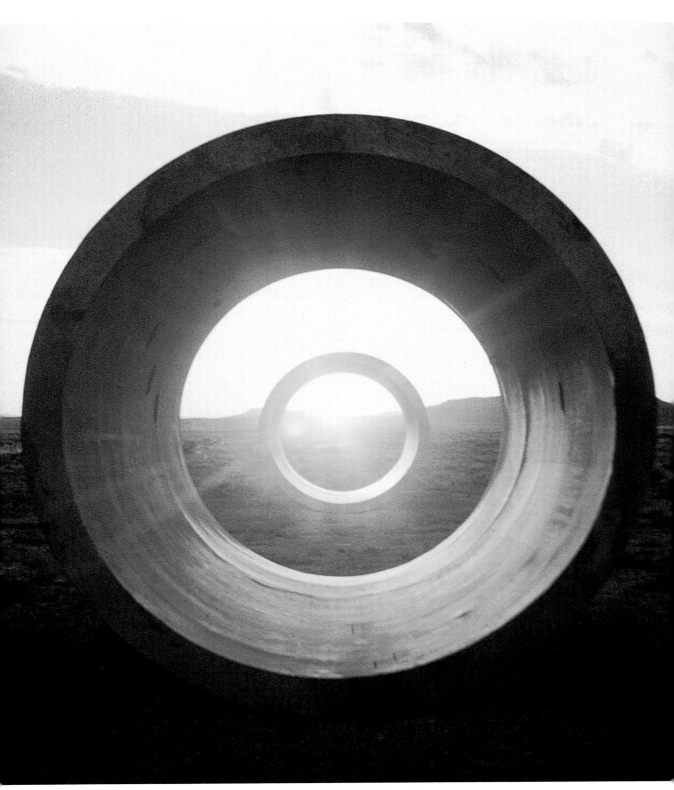

Hydra's Head

Artpark, Lewiston, New York; 6 concrete basins, water, total area 8.50 x 19 m

"Pools of water are the eyes of the earth."

Indian saying

The founding idea for the Lewiston Artpark became the model for all art projects in which areas of the landscape were to be re-cultivated. Located very close to Niagara Falls, the roughly 80-hectare area of the park had been a dump for garbage, chemicals and scrap metal in the decades before 1970. Since the park opened in July 1974, 25 artists have been invited during the summer months to develop projects that deal with this special location. Charles Simonds, for example, installed a circle of sacks of earth containing various seeds that were to sprout during the year, and which represented a growing cycle for edible plants. Alan Sonfist cleared away a circular area of con-taminated soil and refilled it with fresh earth. It was intended to catch blowing seeds and thus promote faster growth in this area. Not all the artistic works were this "ecologically" oriented, but all were removed again at the end of the summer because, unlike permanent collections in museums, the primary intention here was to promote the collective process of the work and present it publicly.

When Nancy Holt was invited to Lewiston in 1974, she installed six water-filled, circular concrete basins in a park path above the Niagara River. The concrete basins had diametres of 60, 90 and 120 centimetres, and were embedded 90 centimetres into the ground. To create an abstract scale model, Holt arranged the water basins' layout and chose their diametres to correspond to the astronomical configuration and light intensity of the individual stars in the Hydra constellation. By entitling it *Hydra's Head*, she additionally alluded to the mythological story according to which the constellation depicts a four-headed monster, the Hydra. Heracles, to whom the task of killing the monster fell, found out that for every head he cut off the monster with his sword, two new heads would grow. Holt also quoted an Indian saying, which calls pools of water the eyes of the earth. These astro-nomical and mythological allusions gave the installation an air of ani-mistic life.

In the periodical *Arts Magazine*, Holt published a description of her work in which she took her poetic idea even further, and mirrored the entire rural setting in the surface of the water in her basins. The sight-lines within this natural hall of mirrors became ever more closely intertwined: "Each drop of rain causes circular ripples to multiply –

circles within circles within circles. Water cascades down a tiny water-fall nearby. Falling water, rushing water, swirling water, still water, sound of water, color of water coalesce here in this place of water, not far from the Falls – their proximity always felt, producing a constant flow of liquid meditations."

Even in her first projects, the poems buried in the landscape, Holt had worked on the boundaries between nature, art and poetry. Every *Buried Poem* (1971) was dedicated to a personal friend, who received a portfolio containing a map, drawings, and directions to the poem's location. Her interest in visualizing constellations has formed another constant in her work, however, most recently in *Sky Mound*, 1988, in which she transformed a 23-hectare landfill in the fields of Hackensack, New Jersey into a large-scale observatory.

Buried Poem # 2, 1971

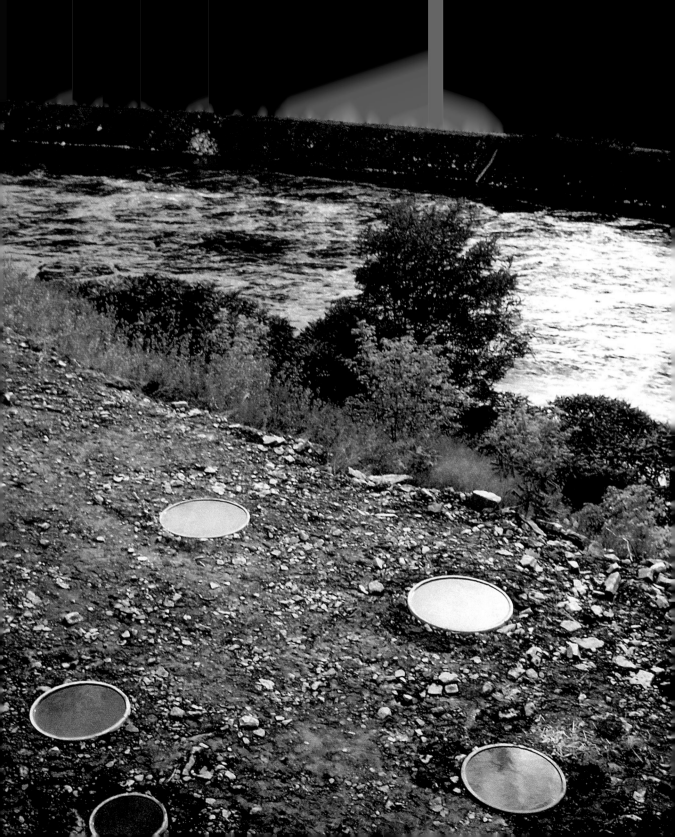

Flower Triangle undersea/ underwater Dam/Threaded calabash

Tobago, Small Antilles; temporary underwater installation

b. 1930 in London, England

In the talk at the 1968 exhibition *Earth Works*, Peter Hutchinson went far back into the history of nature and culture: "Since this planet became solid there have been constant changes in its surface. Geologic eras, meteoritic assaults, floods, storms and erosion have constantly built up, torn down, pitted, smoothed and otherwise sculpted its face … [Man's] very first attempts at civilization centered around agriculture and the first ploughman unconsciously rearranged the planetary surface into symmetrical furrows." In this statement, Hutchinson was primarily paraphrasing his own interests as an artist. The task of art, he argued, consists of composing the earth's surface that is formed by natural history and superior to any "painter's canvas".

In his search for geographically and topographically unusual landscapes, Hutchinson travelled to Provincetown, a small holiday resort at the farthest tip of the Cape Cod Peninsula in Massachusetts. His first action was to spread ordinary lime on the beach. Washed over by the high tide, it dispersed and dissolved into various shapes. Later, thanks to professional diving equipment, he also conquered the ocean, where he planted flowers in straight lines on the floor of the Atlantic.

1969 provided him with new possibilities: The New York Museum of Modern Art commissioned him and Dennis Oppenheim to carry out an exhibition project in the location of their choice. At the end of August both artists flew to the tropical island of Tobago, each to carry out their own plans there separately.

Hutchinson had planned three underwater projects. For *Flower Triangle Undersea* he once again planted flowers on the ocean floor, this time over a triangular area. In *Underwater Dam* he sank twelve sandbags, each weighing 68 kilograms, and with great effort piled them up under water to form a barricade against the current.

Threaded Calabash consisted of calabashes, which he threaded onto a 3.50-metre long rope anchored to a coral reef at a depth of twelve metres. The title is misleading, since a calabash is the dried and water-impervious skin of the gourd. Hutchinson used fresh gourds, however, which drifted back and forth on the rope, decomposed, broke apart, and sank in pieces to the ocean floor.

At the exhibition three months later in the Museum of Modern Art, where Hutchinson showed photographs of his underwater installations, he explained his artistic intentions: "… use of an entirely new environment; use of sculptural means in these new terms – gravity and its opposite flotation; use of free space (space not belonging to anybody); use of entirely organic materials; use of temporary phenomena; experimenting with evolutionary and environmental ideas – one of which is the fact that the sea has no true flowers; use of decaying materials in a positive sense; use of interesting geographical environments and their inclusion in works; photography as a window into this 'past' time of the work; inaccessibility of the work … escape from an art scene which invariably draws one back again (Gauguin is now, of course, shown in museums)."

> **"This piece represented to me the use of a new underwater environment and the use of large color photos as a record and proof that the work was really completed."**
>
> **Peter Hutchinson**

paricutin volcano project

Paricutín, Mexico; 200 kg bread and mould, length 76 m, temporary installation

With his first art projects, the "Tubes", from the year 1969, Peter Hutchinson wanted to use artistic methods to question the scientifically founded opposition between organic and inorganic materials. He filled commonly available Plexiglas tubes with algae, bread and cacti, which through interaction with light and water either grew or began to mould. He wanted to set up these tubes in projects of monumental scale on the edges of volcanoes, icebergs, deserts or mountains, in order to cultivate "growth" in such barren, inhospitable areas. Due to the lack of a sponsor, he failed at the time to realize this idea, which was a mixture between experiment, science fiction and Land Art.

One year later however, in 1970, Hutchinson took up this idea again. He travelled from New York to the Mexican volcano Paricutín, considered a world wonder. According to the story, the volcano emerged with a muffled "plop" on February 20, 1943. One day later it was already ten metres high, a year later 336 metres, and in 1952 it reached its final height of 424 metres. Since then the volcano has become extinct. Hutchinson deliberately selected the spectacular location, a landscape "growing" due to the emanation of molten rock, to create more "growth" in turn. After his initial reconnaissance, he started a regular expedition complete with bearers, horses and donkeys to the crater's edge. In his luggage he brought 200 kilograms of white bread and 90 metres of sturdy, opaque plastic sheeting. Arriving at his goal, he stored the bread in hot crevices in the rock. The next morning Hutchinson spread the bread, which had become damp overnight, along a line 90 metres long on the warm black volcanic slag and basalt rock along the crater's edge. He carefully covered the bread with plastic sheeting in order to create a constant temperature and high humidity, and thereby ideal conditions for the growth of mould spores. After six days he removed the sheeting. The line of bread, which had become an amorphous mass in the meantime, had traded its original white colour for the glowing orange of the mould.

Hutchinson composed a detailed travelogue about his expedition to the volcano, and handed this out as information to visitors to exhibitions of his *Paricutin Volcano Project* photographs. He talked about his arrival in Mexico, his expedition team, the initial difficulties and physical risks of the installation, and spoke of the project's planning and successful execution. The tone of the report differed considerably from comparable artist's texts, such as the fictitious Mexico travelogue published in 1969 by Robert Smithson, entitled *Incidents of Mirror-Travel in the Yucatan*. Hutchinson composed his expedition report in the tradition of 19th-century travelogues, and ended it with a justification of the project: "It is not extraordinary to grow mould on bread. I was not doing so in any scientific sense. I was attempting several other things – to juxtapose a micro-organism against a macrocosmic landscape, yet in such amount that the results would be plainly visible through color changes. I also chose an environment that, although having the necessary elements for growth, needed a subtle alteration on utilization to make growth possible."

> **"Artists today are taking their cues from meteoritic craters and volcanic pits as well as dams, burial mounds, aqueducts, fortifications and moats, to build works that change the surface of the earth."**
>
> **Peter Hutchinson**

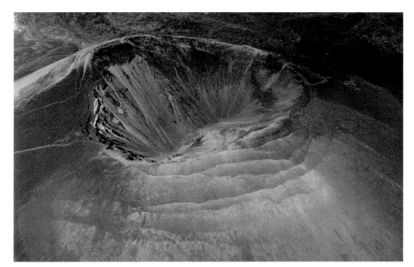

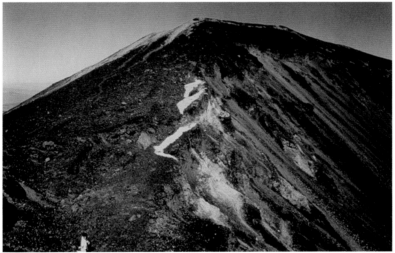

cyrus Field

Buskirk, New York; redwood, marble, cement, area 1.2 hectare

"when you look at 'cyrus Field' what you see is nature."

Patricia Johanson

b. 1940 in New York (NY), USA

In 1968 Patricia Johanson installed a 500-metre long sculpture in an abandoned railroad bed in Buskirk, New York, and named the work *Stephen Long* in memory of that legendary 19th-century engineer and steam locomotive designer. The sculpture does not have any perspective vanishing point. Its extreme length exceeds the limits of its viewers' vision, and seduces them to walk down the path along the sculpture's length. The three streaks of colour – red, yellow and blue – glow so intensely in the changing light and shadow, in contrast to their surroundings, that one could conceive the sculpture's simple linear form as being a part of and a frame for the landscape. As Johanson wrote in an unpublished manuscript, "lines could be construed to be roads, paths, water, bridges or causeways … the line becomes a vehicle for exploring all kinds of other systems contained within: natural light and color, water systems, weather, plants and animals, geology …"

To this day, the drawn line remains the method and strategy behind Johanson's designs for public parks and gardens. From her studies of plant and animal patterns and of microscopic structures, she develops drawings that can be worked back in with nature, without replacing or destroying the existing topography and the ecological balance. She calls these systems of paths "Line Gardens", the interwoven structures of which are so big when executed in large spaces, that the viewer's gaze can only take in parts of them. The linear patterns are initially superimposed on the paper of the drawing, and then on the ground of the landscape – like a camouflage of art.

She based *Cyrus Field* on three designs intended for a large 1.2-hectare tract in a wooded area near Buskirk, New York. Johanson again dedicated her large-scale sculpture to a 19th-century inventor, this time to Cyrus West Field, who worked on the borderline between art, science, and expedition while pursuing his vision for the first transatlantic telegraph connection. Johanson developed her first design out of the geometric form of a subdivided square, the grid structure of which she laid out using white marble blocks in a sparse grove of birch trees. She laid out the second design, a labyrinth on a triangular piece of land, using redwood beams in a thick, dark pine forest. Johanson executed the third line drawing using cement blocks to write her own initials as well as those of her husband Eugene Goossen and her teacher Tony Smith.

The pattern of these designs can only be surmised in the final execution. The paths fit in with the uneven surface of the forest floor, they weather and disappear under leaves, needles, branches and snow over the changing seasons, and yet for viewers they frame the natural surroundings. In an interview, Johanson told of the surprise she experienced when her drawn plans were carried out: "On paper, the design is a simple geometric configuration, composed of identical components. On the ground, each line took on the life of the forest."

Cyrus Field is both an allegorical and programmatic title, and typifies the complex connections between art and nature found in Johanson's site-specific projects to this day.

Stephen Long, Buskirk, New York, 1968

Passages – Homage to walter Benjamin

Port Bou, Spain; steel, glass, olive tree, earth, wind and water

b. 1930 in Tel Aviv, Israel

In 1989 the Arbeitskreis selbständiger Kulturinstitute e. V. turned to Dani Karavan with a request to design a monument to the memory of the German philosopher and literary critic Walter Benjamin. After fleeing before fascist terror, Benjamin committed suicide in 1940 in the little frontier town of Port Bou, on the Franco-Spanish border. In this remote location, which had been a bottleneck in the mass flight of Europeans to America, Benjamin was to be commemorated: and with him all the victims of fascism.

Memorials, monuments and commemorative plaques often seem forced, emotional and eloquently speechless. The frontier town of Port Bou, located on the ocean in the south-east of the Pyrenees, however, has a strangely temporary character, a special aura of transition and impermanence. The large train station designed by Gustave Eiffel dominates the entire place, and the noise of wheels rolling over railroad ties and of manoeuvring railway carriages strengthens the impression of a border location. This atmospheric frontier setting and the natural phenomena of water, light and wind play an important role in Karavan's design for the grounds between the cemetery and the village.

On one hand the title *Passages* plays upon the fragmentary remains of Benjamin's major work, while on the other it underlines the orientation of the work: The viewer should perceive the existing landscape elements, while traversing pathways, stairs and little plazas, as a universal 'limit experience' of human existence.

Thus a downward-leading corridor made of Cor-Ten steel and nestled into the coastal cliffs focuses one's gaze on the rolling sea. On steep, narrow steps, an open passageway leading upward brings you directly to a plate of glass that prevents a fall into the depths, and ultimately forces you to return the way you came. A quotation from Benjamin is engraved on this glass, with which Karavan fends off any rash judgements of the monument. "It is more arduous to honour the memory of the nameless than that of the renowned. Historical construction is devoted to the memory of the nameless." Through the glass plate you can see the foaming and turbulent ocean. If you turn around for the ascent to the closed corridor, you see only a small section of the sky and no firm point of reference.

A little ways above the corridor, a few steel steps direct your gaze to an olive tree: to Karavan, a symbol of peace. Behind the cemetery, visitors can view the distant horizon while lingering on a platform also made out of steel.

From the corridor, the steps in front of the olive tree, and the platform with the seat, a steep rocky path leads to the back entrance of the cemetery. Another natural element of the work, this path refers for Karavan to Benjamin's last path across the mountains.

As the artist explains, landscape becomes a theatrical setting for human tragedy, which in itself already speaks of a hopeless balancing act: "The ocean was quiet. Then suddenly the water swelled up to form a whirlpool, fell back down, and splashed with a powerful white spray on the rocks. Then the ocean was quiet again, as if nothing had happened. This phenomenon repeated itself, with small variations in the sequence. You could see the mountains in the same direction, the Franco-Spanish border, across which Benjamin had attempted to save himself. I thought to myself: … The piece already is there … I only have to get people to see it."

> **"I discovered then that with nature's help, using existing elements, we could relate the story of walter Benjamin."**
>
> Dani Karavan

Schwerer ist es, das Gedächtnis der Namenlosen zu ehren als das der Berühmten.
Dem Gedächtnis der Namenlosen ist die historische Konstruktion geweiht.
Walter Benjamin, G.S. I, 1241

Es una tasca més àrdua honorar la memoria dels éssers anònims que la de
les persones cèlebres. La construcció histórica es consagra a la memoria
dels qui no tenen nom.

Es tarea más ardua honrar la memoria de los seres anónimos que la de las
personas célebres. La construcción histórica está consagrada a la memoria
de los que no tienen nombre.

Honorer la memoire des anonymes est une tâche plus ardue qu'honorer celle
des gens célèbres. L'idée de construction historique se consacre à cette
memoire des anonymes.

It is more arduous to honour the memory of the nameless than that of the
renowned. Historical construction is devoted to the memory of the nameless.

A Line made by walking England 1967

Photograph, 37.5 x 32 cm

b. 1945 in Bristol, England

On walks, forays and bicycle rides, Richard Long has explored the landscape of southern England where he grew up, and where the vegetation and climate would be the defining motivation for his artistic concept. By the mid-1960s he had already developed his idea for "sculpture" in the landscape using extremely simple and unconventional means. For example, he gave the name *Snowball Track* to a line created by rolling a snowball on a slightly snowy lawn. In 1967 he used the landscape's special topography and morphology for his sculpture *Turf Circle Ireland 1967*, for which he cut a small, circular ring of turf out of the ground. In the same year Long also began "walking", and this has remained the subject of his art to this day.

He created one of the first sculptures, which is also his best-known work, by repeatedly walking up and down the same path on a meadow. For a short period of time a line of flattened blades of grass was visible, which Long simply and appropriately named *A Line Made by Walking England 1967*.

The medium he used to present these performative works in exhibitions was photography. These are always extremely simple and direct photos, which nonetheless comprise more than just pure documentation. Leading into the pictorial depths, the linear pathway shown in the photograph *A Line Made by Walking England 1967* divided the picture into almost symmetrical halves, and thereby increased the contrast of the "line" with its surrounding landscape of meadow and trees. The simple, almost geometrical pictorial formula, the black-and-white coloration, and a certain slight fuzziness of pictorial depth, emphasized the motif's graphical quality and effectively contrasted the linear structure with the grainy, matte surface of the photographic paper.

In the following years, Long reworked, in ever-new variants, the walk in the landscape that had been planned as a line. Thereby he superimposed various pictorial levels, be they maps, photographs, drawn lines or texts. For *A Ten Mile Walk England 1968*, he drew a straight line across the map of the well-hiked highlands of Exmoor and inserted the word "Start" at one end of the line. The drawn line stands out clearly from the topographic map's thick network of elevation lines, streets and paths. It marks the track of the hike he planned as a straight line, but which lost its linear alignment due to existing natural conditions. In another work Long jotted down lines from the popular Johnny Cash song *I Walk the Line*, associated with an unmistakable rhythmic mood, beneath a photograph of two lines of stones he had laid out in a shallow river bed that intersected at one point.

Long has hiked along previously determined routes or traced out basic geometric forms through many landscapes since the 1960s. Whether in the familiar regions of England and Scotland, or in distant parts such as Alaska, Africa, Bolivia or Nepal, he has crossed bogs and mountains, or followed river courses. As in *A Line Made by Walking England 1967*, his careful and restrained way of dealing with nature and the simplicity of his means characterize his complex works: "The source of my work is nature. I use it with respect and freedom. I use materials, ideas, movement and time to express a whole view of my art in the world."

> "I like simple, practical, emotional, quiet, vigorous art. I like the simplicity of walking."
>
> **Richard Long**

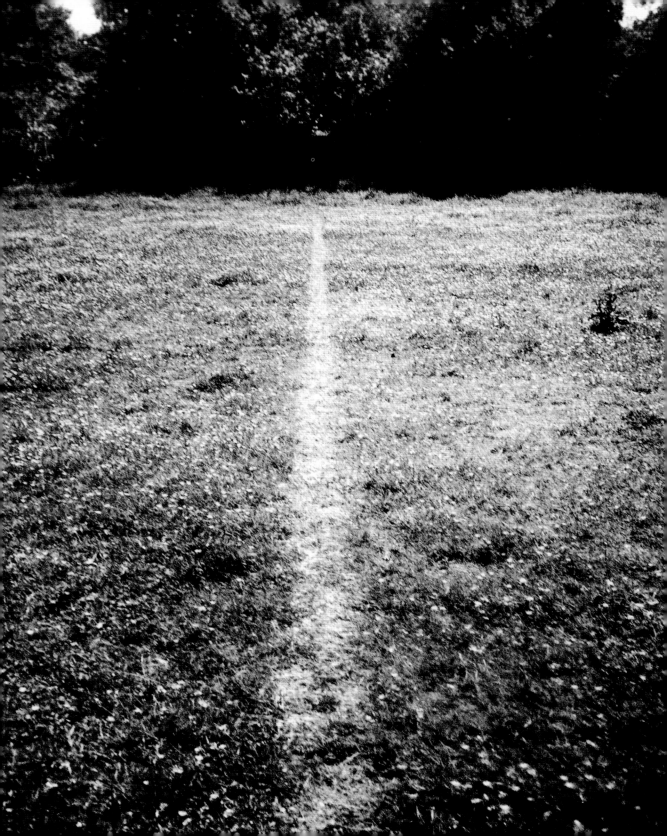

A Line in the Himalayas 1975

Photograph, 124 x 88 cm

Richard Long confesses: "I like the simplicity of walking, the simplicity of stones. I like common materials, whatever is to hand, but especially stones. I like the idea that stones are what the world is made of. I like common means given the simple twist of art. I like sensibility without technique." In the practice of artistic creation there is hardly any other material used as often as stone. Its properties – a stone is solid, heavy, and retains its form – are proverbial. Stone expresses and witnesses natural history, and has the closest possible connection with geological processes. Long alludes precisely to stone's permanence and unchangeability, and to its elementariness and temporality, when he forms lines, crosses or circles from stones that he finds in the landscapes he wanders through.

Most of these sculptures' stones remain distanced from the observer, since they stay in their place in the landscape. They become symbols of Long's presence, a direct reaction to the selected location, created from the impressions invoked by walks that often last for days. Time of day, weather and location can play just as much a role in this as the stones' weight, form, and colour, and the artist's physical state during the hike can have an important influence in their formal arrangement.

Long presents his work primarily through photography. "I just step back," he explained in an interview, "and point the camera and try and get in focus. Even though it is necessary to get a good photograph, the photograph should be as simple as possible so that when people look at the photograph they are not dazzled by wide-angled lenses or special effects. Because my art is very simple and straightforward, I think the photographs have got to be fairly simple and straightforward … " In his search for the simplest and most direct form, Long has also used black-and-white and colour photographs that he mounts on large white pieces of cardboard, and then presents with hand-written indications of title, location, and time of the hike. He always presents these photo-text works, like *Stopping Place Stones* of 1974, in a simple brown frame.

It is the simplicity of the presentation that calls to mind the intrinsically complex experiences and encounters that comprise a hike. This is the most direct means for depicting the sculpture's inescapable absence. The photograph is only a stand-in for the sculpture, but one that the artist attests to, both through his handwriting and the selected details.

Notwithstanding this, the lines possess their own graphical intensity in photographic images. In *A Line in the Himalayas 1975*, a narrow and almost fragile line of light-coloured, smaller stones, lies like a pencil stroke on a field of boulders and rocks before a breathtaking scene of snow-covered mountaintops. The blue and grey hues, as well as the line's light colouration and thinness, betray something of the location's altitude and cold, of breathlessness and exhaustion. Thereby the line fits unobtrusively into the picture of the landscape, and seems like a coincidental, natural accumulation. Long has worked with this method in many variations. In *A Line in Ireland 1974*, a line of grey stone appears on the barren landscape's stony, uneven ground, like a momentary solidification of the brittle, rocky soil. The photograph of *A Line in Australia 1977* shows a line of scattered red stones, their loose, flat structure harmonizing with the desert landscape.

Stopping Place Stones, 1974

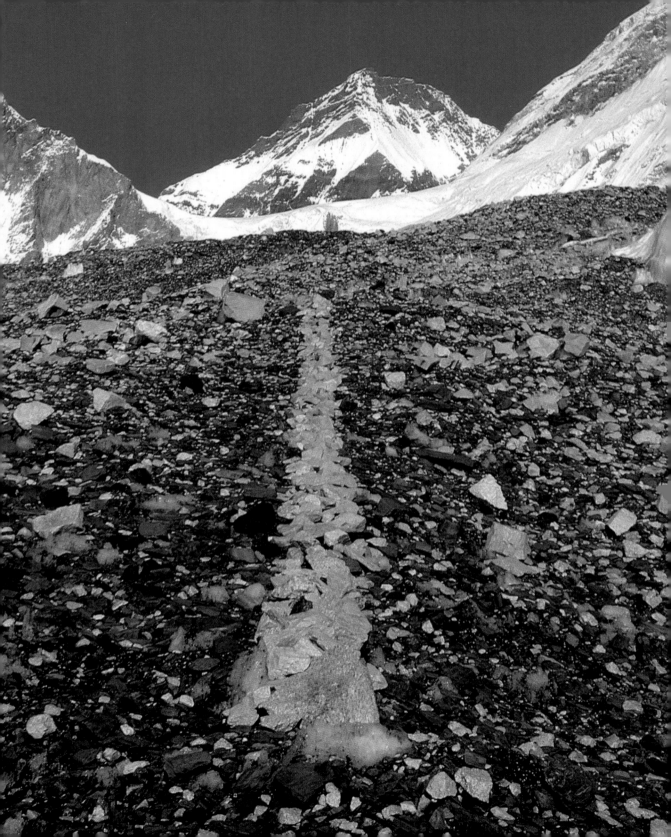

A Line of 682 stones

Installation in the British Pavilion, 37th Venice Biennale

Since its founding in the year 1895, the Venice Biennale has been subject to the criticism that, due to its separate exhibitions in individual (country) pavilions, no international dialogue takes place, but only the national representation of participating countries. A new dimension of sculpture and a different cultural practice, however, characterized the extremely successful 37th Venice Biennale in 1976. The responsible organizer, the Italian art critic Germano Celant, had deliberately selected the title *Ambient/Art*, in order to give the theme he had preset, of designing and structuring space by artistic means, a critical and contemporary flavour. No longer were exhibitors to present "autonomous" artistic objects in the most neutral spaces possible, but to show "situations" instead. Celant collected a number of artists whose work he saw as a manifestation that countered the artwork's isolation from time, space and social context. The investigation being undertaken here, as he explained in an exhibition catalogue, concerned the conditions and methods of the interaction between art and its environment.

For his contribution to the Biennale, Richard Long laid three parallel lines of a total of 682 stones through several rooms on the British Pavilion's stone floor. The Pavilion, originally a restaurant, was renovated in 1909, and with its open loggia and grand staircase it is still more elegant and inviting than many other pavilions. Its interior consists of a large central room and surrounding smaller rooms. The parallel lines of stones led through the rooms without interruption in this bright and open atmosphere. The rectangular shape of their layout was not visible to viewers as a whole, however, because the walls and doorways only revealed a section of the work at a time. Therefore even a photograph could only provide a very limited impression of the installation. Viewers felt called upon to walk along the lines, to cross the space beside and above the stones, and thus to carry out the artistic gestures of hiking, collecting and placing with their own bodily movements.

Long had sought unconventional forms for museum exhibitions as early as 1969. In the garden of the Krefeld museum's Haus Lange – not in its interior rooms – he created an exhibition that ran more than a year, for which he built interventions in the ground's surface in various locations around the garden. The slightly rolling large grass ring entitled *Turf Circle* still exists today. The installation at the Biennale was also site-specific in the sense that it was inseparably associated with the pavilion's structure and surface.

Long has always emphasized his interest in the direct confrontation between viewers and the concrete, tangible stones, laid flat on the exhibition room floor. He strongly resists any interpretation of his work as a romantic flight from nature or as culture-critical pessimism, because his sculptures' imaginative significance only becomes apparent in their interaction with a given location: "My work is real, not illusory or conceptual. It is about real stones, real time, real actions. My work is not urban, nor is it romantic. It is the laying down of modern ideas in the only practical places to take them. The natural world sustains the industrial world. I use the world as I find it."

"My art has the themes of materials, ideas, movement, time. The beauty of objects, thoughts, places and actions."

Richard Long

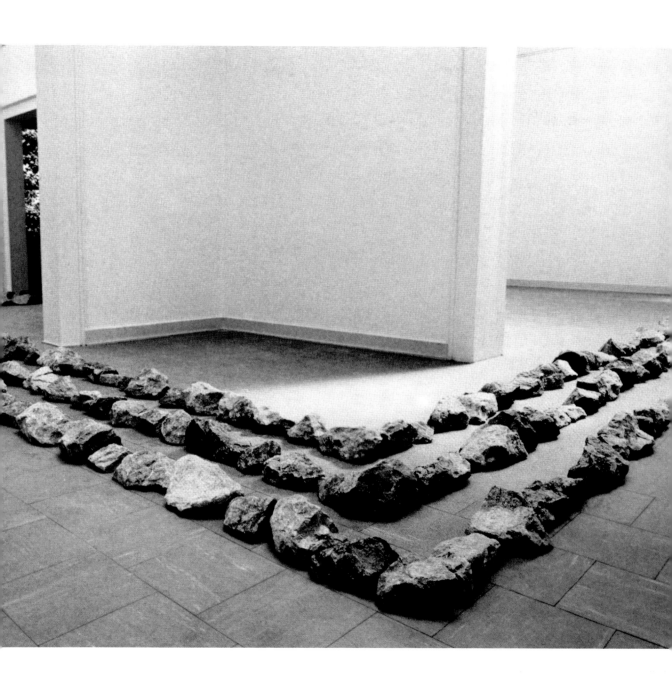

Perimeters/Pavilions/Decoys

Wood, steel, earth, maximum height 5.50 m, excavation 12 m^2
Nassau County Museum of Art, Roslyn, New York

b. 1944 in New York (NY), USA

In order to see *Perimeters/ Pavilions/Decoys*, viewers of this work by Mary Miss first had to find it. Miss executed this complex structure of buildings for the Nassau County Museum on a 1.6-hectare green area protect-ed by thick brushwood and trees, incorporating the location's par-ticular topography and structure into the work. One could not label the site-specific work sculpture or architecture, and its later re-moval logically meant the work's destruction. The title already hints that the work consisted of rooms that either opened out or closed off, and of "perimeters", "pavilions" and "decoys", but one could only experience their structural complexity on site.

Upon entering the area, one first saw three tower-like buildings. These were made of long, narrowly spaced wooden posts rammed into the ground to form a square outline, and then stabilized with four narrow wooden platforms. A light-transmissive metal lattice screened the spaces between the platforms. The tallest of the towers measured 5.50 metres, the second tallest 4.50 metres, and the building at the perimeter of the property only 3.60 metres. Here the upright posts were so close together that one could no longer step between the gaps. Any association with skeletal towers that one could climb or in which one could hide, changed at the sight of the third building to ideas such as barriers, blockades and obstacles.

If you continued along, you arrived between two semicircular, rounded hills of earth added rather unobtrusively to the site's surface, and you also found a ladder jutting out of a square shaft in the ground. If you climbed down into the pit, you would be surprised to find your-self in an underground courtyard, the area of which was considerably larger than one would have expected from the size of the entrance. With wooden posts and wooden walls, Miss had created a complex underground spatial structure with a walkway around its perimeter. In the exterior walls of these corridors she had cut openings that were, however, only large enough to look into. One got the impression that the inaccessible space behind these window- and door-like openings extended further as an underground labyrinth into the dark earth.

The large-scale installation above and below the surface of the earth forced viewers to rove about the place, to climb up and down, and to be constantly reorienting themselves in the area. One's view of the surroundings changed when one stepped between the towers' rigid wooden posts, climbed up onto the platforms screened by metal lattice, passed among the earthen hills' rounded domes, or climbed down into the underground courtyard. An allegorical interpretation of this site-specific work as a ruin of the ostensibly self-evident, natural structures of (living) rooms truly forces itself upon the viewer, and Miss expressly confirmed this interpretation in a later interview: "For me, the 1970s were about dismantling things, about taking structures apart, whether these structures were the role of women, the idea of sculp-ture, or the notion of appropriate content."

"The work I have done has always had a realistic physical motive rather than an abstract or conceptual basis."

Mary Miss

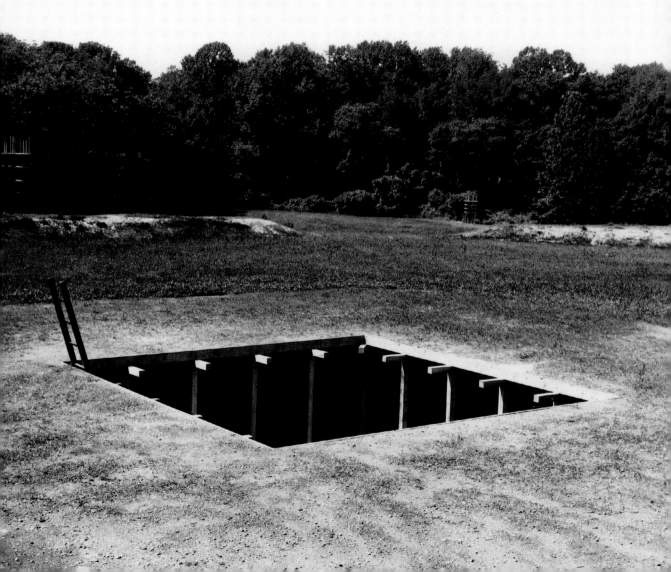

observatory

Oostelijk (Flevoland), Holland; earth, grass, wood, steel, granite, water, Ø 91 m

b. 1931 in Kansas City (MO), USA

For the international group exhibition Sonsbeek '71, Robert Morris was given the opportunity to carry out his plans for a quasi-architectural, large-scale observatory. Curator Wim Beeren organized the exhibition not just in Sonsbeek Park in Arnhem, but in various locations throughout Holland, in order to offer every artist an environment corresponding to their artistic interests. Morris searched for a suitable place on the periphery, in a zone between ocean, land and city, which he finally found close to Santpoort (Velsen). It is not just in terms of cost and construction-time that plans differ from the observatories conceived by Charles Ross or James Turrell. Morris' *Observatory*, which was demolished after the end of the Sonsbeek '71 exhibition, remained by programmatic intention on the narrow borderline between sculpture and architecture.

It consisted of two concentric rings of earth, which in this location were inevitably reminiscent of a dike. The outer ring with a narrow water-ditch had an undulating shape, and was divided into segments by a triangular entrance and two V-shaped indentations in the mounds. For the inner ring, earth was dumped against a palisade made of wooden slats, in which four openings had been cut beforehand. From a westerly direction viewers came to an axis oriented eastward in the area of the inner ring. Here, two of the openings were lined up with notches on the outer ring, which were reinforced by solid granite slabs and oriented on the sunrise during the summer and winter solstices. On the prolongation of the axis beyond the two rings, one looked out at a third indentation marked by two large, square steel plates, which the sunrise accentuated during spring and autumn equinoxes.

In 1977 Morris, in cooperation with the Stedelijk Museum in Amsterdam, was able to rebuild the work in Oostelijk (Flevoland) in Holland. The structure is now overgrown by grass and fits unobtrusively into the polder landscape: the very flat marshland reclaimed by using dikes.

The circular, axially oriented spatial structure and the various views out of and into it are intended to imply movement, just as was also characteristic (Morris believes) of prehistoric observatories. "The overall experience of my work derives more from Neolithic and Oriental architectural complexes. Enclosures, courts, ways, sightlines, varying grades, etc., assert that the work provides a physical experience for the mobile human body ... The work's temporal focus – the marking of the four annual sunrises of seasonal changes – moves it beyond a simple, decorative spatial structure." The definition of sculpture supported by the arguments of phenomenology and Gestalt psychology, and which Morris represented in the 1960s, echoes in these sentences. At that time, he led the call for constant, simple forms, so that varying perceptions of the sculpture in space could arise due to its gestalt, its shape. The particular site of the presentation is also of decisive significance for *Observatory*: "The work lies in that buffer zone or interface between the wild and the inhabited ... It is on that boundary, at the beginning of the dunes, that the work exists – not as an enlarged photograph of a remote monument, but as an accessible place between the cultivated and the natural."

> **"The observatory is different from any art being made today ... The work provides a physical experience for the mobile human body."**
>
> **Robert Morris**

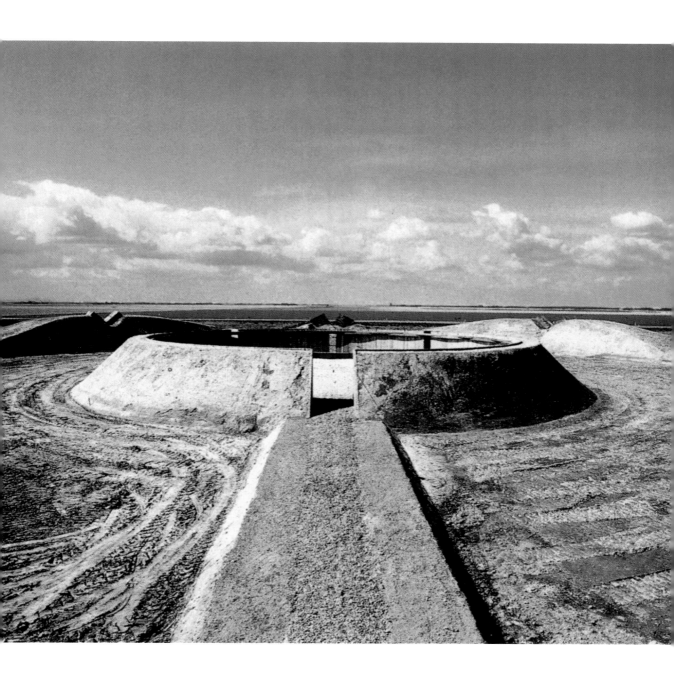

circle x Branded mountain/ anthrax/Diphtheria

Photo and text collage, 102 x 80 cm
Sammlung Marzona, Nationalgalerie, Staatliche Museen zu Berlin

b. 1938 in Mason City (WA), USA

Dennis Oppenheim is among the pioneers of Land Art. Since the mid-1960s he has tried to use landscape as material and, as he himself puts it, to get under the earth's surface. In 1969 he carried out numerous projects in selected locations in the US and Canada, all of which were temporary and short-term. As a result, hardly anyone has been able to actually see his work, since the pieces soon disappear again and only become known through documentation. For *Circle X Branded Mountain*, Oppenheim marked the grass surface of a hill near San Pablo, California, with a brand mark in the form of an X inside a circle. He carefully selected its 17-metre diameter to make the brand easily recognizable in an aerial photograph, and yet still provide enough space to allow cows to continue grazing in this marked location – an abstract symbol of their own bodies.

Oppenheim searched for deserted, desolate areas, as he emphasized in a later interview: "I was drawn to ravaged sites … If the land wasn't degenerate enough for me, I'd write words like 'diphtheria' on the hillside. The idea was a severe disjuncture from the pastoral." Thereby he was alluding to his project *Diphtheria*, in which he dug that word in big, plain letters across 30 metres of a dry riverbed. The site was near Boise, the capital of the US state of Idaho, known for its vast recreation area extending along the riverbank.

With the single word "diphtheria" – a bacterial infection of the respiratory tract – Oppenheim shifted the river landscape's idyllic image towards the idea of an "infected zone". *Anthrax* was a variant of this procedure. Anthrax is an infectious disease, an unusual feature of which is the use of anthraces as a biological weapon, which was only prohibited in 1972 in an international agreement. Oppenheim burned a 23-metre version of this word onto the side of a hill.

All three projects were site-specific and temporary. Oppenheim could therefore only exhibit them in other locations in the form of photography. In an interview he told of his initial difficulties: "You can't understand how strange it was to be a sculptor who exhibited photographs. You operated on a truly large scale, but when photographs represented the work everything closed down into a pictorial configuration. You were always making excuses for poor documentation, saying what you were doing was an advanced art, and there were only a few ways to communicate it. But in reality the work was gone, and there was nothing to see. That was the way I wanted it."

Oppenheim repeatedly declared that he actually showed no photographs and was rather careless about the presentation of his work. His documentation was actually provocatively cursory, and thereby demonstrated a disinterest in exhibitions. This was immediately interpreted as a statement of opposition to the art business. Despite the improvised form of presentation, Oppenheim very carefully selected the materials that defined his working process: aerial photographs, satellite pictures, topographical maps, texts and views of exhibitions. This unconventional means of presentation allowed him to succeed in decisively shifting the viewer's attention onto the work in the landscape.

"The work is not put in a place, it is that place."

Dennis Oppenheim

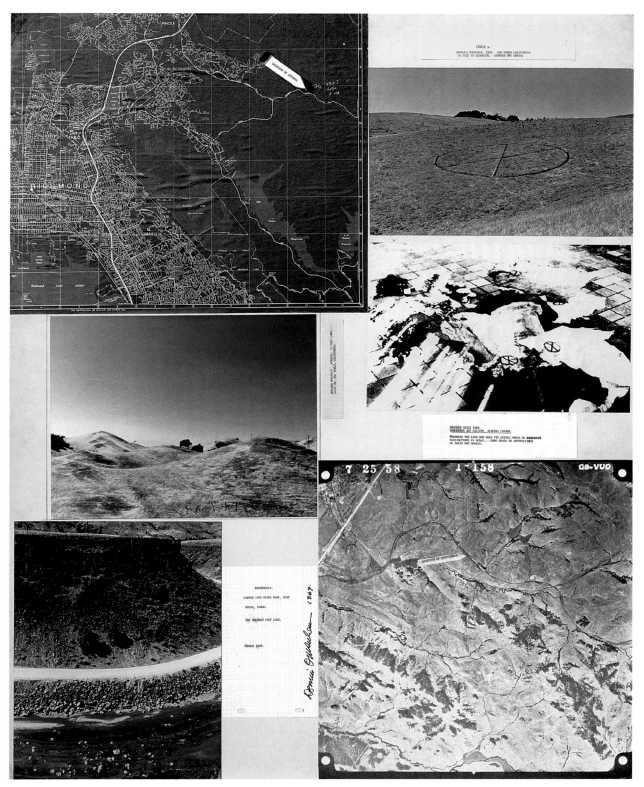

whirlpool – Eye of the storm

El Mirage Dry Lake, California; liquid nitrogen from a tank in an airplane,
Ø of the circular form 1.2 km, duration 1 hour

> **"It seems to me that one of the principal functions of artistic involvement is to stretch the limits of what can be done."**
>
> **Dennis Oppenheim**

For his project *Whirlpool – Eye of the Storm* Dennis Oppenheim chartered two airplanes in the summer of 1973, and had them take off from the El Mirage Dry Lake desert in California. One airplane had a photographer on board; the other was to leave a trace of white smoke behind it along spiral-shaped flight paths. The artist radioed instructions for the flight manoeuvres from the ground. The airplane first flew in a wide circle with a diameter of 1.2 kilometres, and then proceeded to fly a pattern of ever-narrower, ever-lower circles. They had to repeat this undertaking three times, until the vortex pattern the artist had envisaged appeared and held its shape for several minutes.

Oppenheim wanted to transfer in schematic form the linear structure of a vortex or whirlpool into the desert. With the title adjunct "Eye of the Storm" he was alluding to another natural phenomena, the hurricane. Ascending air masses over the warmed ocean surface create a tropical cyclone. Once this mass begins to rotate it creates a large-scale vortex. The so-called "eye" is a characteristic feature: a windless zone with no precipitation and few clouds in the centre of the hurricane. After locating a cyclone, airplanes are sent with the dangerous task of collecting data in the hurricane's centre. Oppenheim parodies the spectacle of danger and heroics that surrounds these pilots, the "hurricane hunters". The bizarre location with its elementary contradiction – a lake that has dried to become a desert – becomes a metaphorical projection surface for the vortex's white lines, which at worst could represent a danger to the conventions of the art world.

Around 1970 the desert experienced a boom. It became not only the site for spectacular "earthworks", but also a setting for rock musicians such as Jim Morrison, and for American road movies, science-fiction films, and avant-garde cult films such as *Zabriskie Point* by Michelangelo Antonioni. The commanding view of the desert is thereby the view from above looking out of an airplane, which offers an unforeseeably broad field of possible strategic and aesthetic interpretations.

Oppenheim searches for such special locations. In *Annual Rings*, 1968, he cut the pattern of a tree's growth rings into the frozen ice surface of a border river (which is also a time zone boundary) between the US and Canada. He sees the desert, on the other hand, as the place that contrasts the most with art's familiar spheres of action. Additionally, the desert is flat and of almost monochrome coloration.

"A good deal of my preliminary thinking is done by viewing topographical maps and aerial maps and then collecting various data on weather information," Oppenheim declared. "… So this is an application of a theoretical framework to a physical situation." He sees the transfer of information from a two-dimensional surface onto a real place as a formal process, but one that radically differs nonetheless from vehement gestures such as those of Abstract Expressionism. If one wants to work in the landscape, according to Oppenheim, one should not use patterns and forms worked out in the studio. The abstract patterns of lines confer another, broader field of association onto the landscape. They can indicate political borders, time, rain, temperature, altitude or even a storm. Robert Smithson, explaining Oppenheim's process, said that he changes a piece of landscape into a map: a very specific occupation, which is interested in the transfer of information.

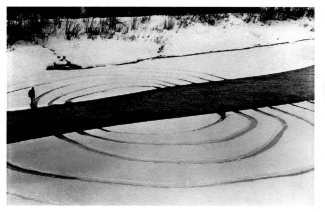

Annual Rings, 1968

star Axis

Chupinas Mesa, New Mexico; earth, concrete

"A place where the sky touches the land."

Charles Ross

b. 1937 in Philadelphia (PA), USA

According to a physical formula difficult to interpret, the visible spectrum of light is electromagnetic radiation with wavelengths between about 400 and 750 nanometres. Since the mid-1960s, Charles Ross has been confronting the terminology of science with the aesthetic experience of the colours of the visible spectrum. For him light is an energy that becomes visible when it is refracted by other media. If light passes through a transparent medium like glass or water, the light's speed changes, and this refracts the light beam. Ross designed Plexiglas prisms filled with mineral oil, which spread the colours of the spectrum across nearby opaque surfaces. In 1968, Michael Heizer described the forceful, convincing experience of Ross' prisms: "They are transparent, translucent, reflecting, mirroring, distorting, magnifying, refracting, bulging, fragmenting, compressing, repeating, and altering what is immediate to themselves."

After Ross had shown his glass prisms in galleries and public buildings, he began to seek a location for a light installation of significantly larger dimensions. After many years of searching, he finally found a location 2220 metres above sea level in a lonely region of a New Mexico desert.

The project *Star Axis* attempts to make the earth's space-time changes tangible, and is oriented on a millennia-long cosmic cycle. The title refers to the axis around which our planet rotates and the phenomenon of precession (Lat. *praecedere* = to proceed). Since the earth is not a perfect sphere, the gravitational pull of the moon and the sun create a torsion force that attempts to straighten the earth's axis and leads to its precession. The earth requires around 25,750 years for a full precession cycle, and over this time span it describes a specific circle in the heavens. Precession causes the regressive movement of the vernal equinox; today it lies in the astrological constellation Pisces, and beginning in the year 2600 it will move into Aquarius: a

cosmic constellation that Ross wants to make visible in the five-part structure of *Star Axis*.

The heart of the observatory is a 60-metre long staircase oriented on the earth's axis, the *Star Tunnel*, which leads from the foot of the mesa through a steep passageway to the plateau. The *Equatorial Chamber* is located at this tunnel's entrance. The chamber is aligned so that through its uppermost opening one can see the stars that pass the equator. The walk through the tunnel leading upward from this chamber is a type of astronomical ladder of time. On the lowest step you can see the circle of the heavens showing Polaris at its closest to the celestial pole. With every step you take, more stars move into your field of vision, and this corresponds to that section of the heavens across which the rotational axis wobbles during a specific epoch. Other buildings on the plateau, which are almost complete, the *Solar Pyramid* and *Hour Chamber*, are further structures for projecting the movement of sunlight and cast shadows.

The complex, site-specific idea for *Star Axis* was born in the era of American moon landings. For Ross, the trivial images of these landings were not adequate to express this expansive experience: "Although advanced technology has placed us in the age of space exploration, contemporary circumstance gives little opportunity for us to recall our sense of being in the stars. Star Axis offers a place for that remembering."

Prism Skylight, Spectrum Building, Denver, Colorado, 1980

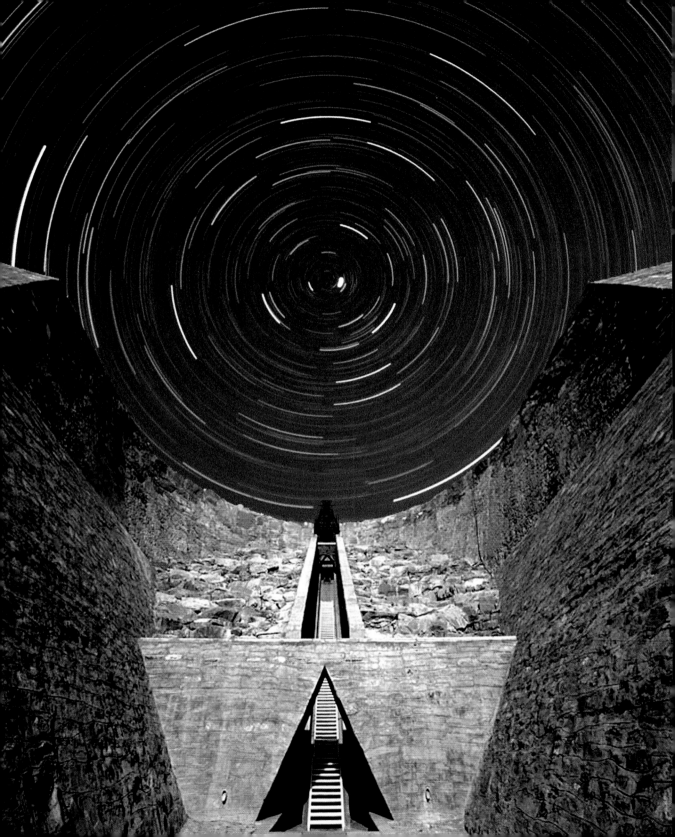

Nonsite, oberhausen, germany

Five enamelled steel containers with slag, 25 photographs, and pencil on a photocopied map
Flick Collection

b. 1938 in Passaic (NJ),
d. 1973 at Tecovas Lake (TX), USA

By the time of his premature accidental death in 1973, Robert Smithson had become a key figure in Land Art. Besides the diverse sculptures, films and drawings he produced, his theoretical texts were primarily responsible for his (self-declared) position as a spokesperson for the art that was taking place beyond the boundaries of studios and art institutions. His articles, lectures and interviews are a brilliant and boisterous mixture of art criticism, of scientific theories of thermodynamics, crystallography and geology, of media theory, of science fiction and horror films, and of the theory of postmodern literature and symbols. These texts are an important reason for his cult status today.

Smithson invented the labels "Site" and "Nonsite", thereby announcing the tension between exterior and interior space. With these conceptual notions he attempted to compose a real and traversable "place" in exterior space in such a way that it would change into a transportable and abstract artwork: the "Nonsite". He placed materials collected from the outdoors into metal containers that were reminiscent of his minimal sculptures' serial organization and geometric vocabulary of form. On the exhibition wall parallel to these he showed texts, photographs and maps of the location. These were dissimilar analogies and metaphors for the non-present places. "By drawing a diagram, a ground plan of a house, a street plan to the location of a site, or a topographic map," explained Smithson, "one draws a 'logical two dimensional picture'. A 'logical picture' differs from a natural or realistic picture in that it rarely looks like the thing it stands for."

Smithson conceived most of the "Nonsites" during 1968. That October, he showed a "Nonsite" for the first time in the groundbreaking exhibition *Earth Works* at New York's Dwan Gallery. When gallerist Konrad Fischer invited him to Düsseldorf at the end of the year, he went on an excursion to the waste dumps of the Ruhr district with industrial photographers Bernd and Hilla Becher. Smithson collected slag, a waste product from steel mills, in the extensive industrial landscape around Oberhausen, and photographed the ravaged, abandoned area. In the gallery he then presented five progressively taller painted steel containers, into which he had simply dumped the slag. On the gallery wall he exhibited photo collages: 25 snapshots of the area were arranged in five rows of five photographs. Below these was a photocopied map of the industrial area, on which the slag's site of origin was highlighted. Below the map, handwritten notes provided purely factual information about what one could see there (map number, size and colour of the containers, etc).

"What you are really confronted with in a nonsite is the absence of the site," Smithson emphasized in an interview later, "It is a contraction rather than an expansion of scale. One is confronted with a very ponderous, weighty absence. What I did was to go out to the fringes, pick a point in the fringes and collect some raw material. The making of the piece really involves collecting. The container is the limit that exists within the room after I return from the outer fringe. There is this dialectic between inner and outer, closed and open, center and peripheral. It just goes on constantly permuting itself into this endless doubling, so that you have the nonsite functioning as a mirror and the site functioning as a reflection."

> "The Nonsite (an indoor earthwork) is a three dimensional logical picture that is abstract, yet it represents an actual site. It is by this three dimensional metaphor that one site can represent another site which does not resemble it."
>
> **Robert Smithson**

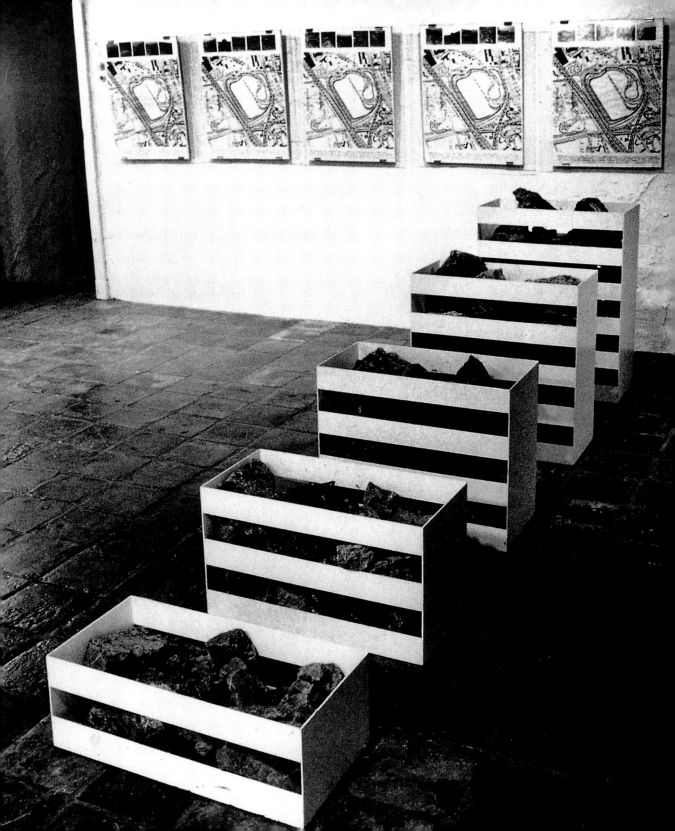

spiral ɹetty

Rozel Point, Great Salt Lake, Utah; 6783 tons of rock, earth, boulders, salt crystals, algae, water,
length 450 m, width 4.50 m
Dia Art Foundation, New York

==

Spiral Jetty was the name Robert Smithson gave to his basalt rock, boulder, mud, salt crystal and algae strewn spiral in the Great Salt Lake in Utah. Close to the wrecks and scrap metal remaining from the lake's industrial exploitation, this coiled earth sculpture appears more like a grotesque parody of a jetty, yet Smithson selected the sculpture's spiral form and bleak location very carefully.

He travelled to Utah in his search for a Salt Lake with a red tinge, and finally found a location on the Great Salt Lake's north bank, where the water was shallow and of a pale red colour. "As I looked at the site, it reverberated out to the horizons only to suggest an immobile cyclone while flickering light made the entire landscape appear to quake … This site was a rotary that enclosed itself in an immense roundness. From that gyrating space emerged the possibility of the *Spiral Jetty*." Smithson reported this revelatory experience in his text *Spiral Jetty*, first published in 1972. There he also described the beginning of construction in April of 1970, the risky work with dump trucks, tractors and front-end loaders on the brittle lakebed, his ruminations about crystal forms, the sculpture's size and scale, and the shooting of his film. This rather factual report suddenly takes on a different tone and becomes a trip into prehistoric times: "Chemically speaking, our blood is analogous in composition to the primordial seas. Following the spiral steps we return to our origins, back to some pulpy protoplasm, a floating eye adrift in an antediluvian ocean … My eyes become combustion chambers churning orbs of blood blazing by the light of the sun."

He had almost 7000 tons of material dug out of the banks and dumped into the lake. Since scarcely anybody visited the remote location in Utah, and especially since the sculpture sank below the water's surface from 1972 until 1993, it became famous primarily through photographs made by Gianfranco Gorgoni. Smithson publicized the earth sculpture by means of his extensive text *Spiral Jetty*, however, as well as through articles contributed to the magazine *Artforum*, and exhibitions in which he presented the film.

This was an unconventional and complex system of references to the location, and the sculpture's significance threatened to sink in a whirlpool of different readings and viewpoints. On the film poster, for example, were printed not only the precise storyboard drawings for the film, but also passages from *The Unnamable* by Samuel Beckett, from *The Time Stream* by John Taine, and from geography and crystallography reference texts. Further details refer to the soundtrack, such as the ticking of a metronome or the clattering noise of a Geiger counter.

While the film poster is a flat, graphical representation of the earth sculpture, in the film itself Smithson works with cinematographic processes, with sound and image montage, with camera image movement, with cuts and composition, and with zooms and slow motion. "Adrift amid scraps of film, one is unable to infuse into them any meaning, they seem worn-out, ossified views, degraded and pointless, yet they are powerful enough to hurl one into a lucid vertigo." Whatever means Smithson used to exhibit his earth sculpture, so remote that only a few visitors could reach it: it became an imaginary object, present and absent simultaneously.

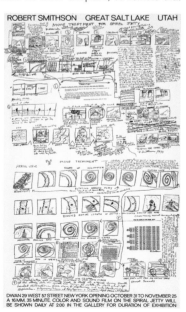

Poster, Dwan Gallery, New York, 1970

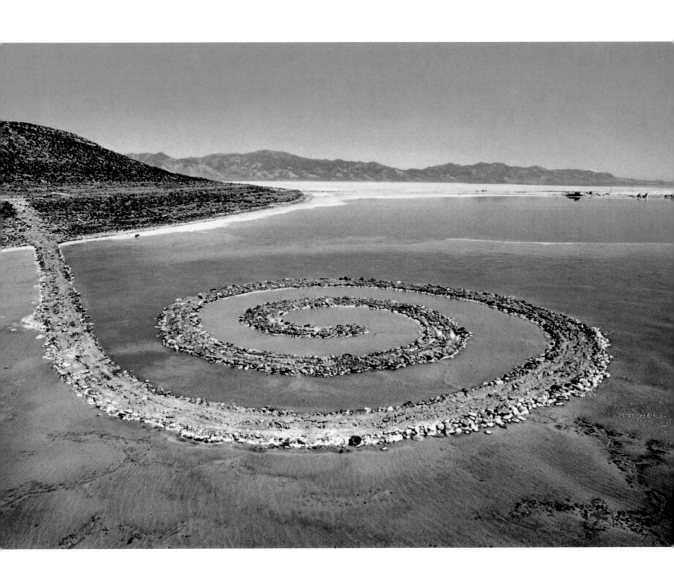

вroken circle/spiral нill

Emmen, Holland; sand, earth, water, Broken Circle Ø 43 m, Spiral Hill Ø 23 m

> "тhe world needs coal and highways, but we do not need the results of strip-mining or highway trusts … аrt can become a resource, that mediates between the ecologist and the industrialist."
>
> Robert Smithson

Broken Circle/Spiral Hill is the first and only project in which Robert Smithson was able to use an industrial area for his idea of artistically recultivating the landscape. This project received its impetus from an invitation to create an artwork in a park at the Sonsbeek '71 exhibition in the Dutch municipality of Arnhem. "The idea of putting an object in a park really didn't motivate me too much," said Smithson in an interview. "I was looking for an area that was somewhat raw because Holland is so pastoral, so completely cultivated and so much an earthwork in itself that I wanted to find an area that I could mould, such as a quarry or a disused mining area." He was thus very responsive to the idea of curator Wim Beeren, who wanted to present the exhibition not just in Sonsbeek Park, but in various locations around Holland. When Smithson, through the organizers' mediation, learned of sandpits with green lakes, he began to draw up plans for a combination of jetty and canal laid out in a circular configuration.

He finally found an ideal sandpit for his plans on the outskirts of Emmen, which was already slated for transformation into a resort. "The quarry itself was surrounded by a whole series of broken landscapes, there were pasture lands, mining operations, and a red cliff – it was a kind of sunken site." This site possessed the forms and deposits that Smithson had been looking for: traces left by various uses, coloured surfaces, and highly varied types of earth and stone. "The quarry happened to be on the edge of a terminal moraine. During the last ice age, the glaciers moved down there and deposited all different kinds of materials, mainly sand. The area was made up of red, yellow, white, brown and black earth, with boulders that had been carried by the glaciers and tumbled into a round shape."

In view of the location, Smithson enlarged upon his initial design. He had *Spiral Hill* raised at the lakeside and covered with a layer of red earth, upon which a spiral path strewn with white sand led upwards. As its counterpart, he built *Broken Circle* jutting out into the lake. The design was based on a circular area divided into two half-circles. A ring-shaped canal cut through one half-circle made of sand, while an exterior ring of sand bordered the other half-circle made of water. It was only by coincidence that a gigantic boulder lay in the enclosure's centre. It could not be moved, and remained where it was, "… as a kind of glacial 'heart of darkness' …"

Smithson attempted to offer similar designs featuring linear forms made of broken circles and spirals, or structures such as jetties, dams, and canals, to companies in the US for recultivating their open-pit mining areas. He found, however, that there was no interest in using such minimal accentuation of the landscape to make the traces of industrial encroachments more visible, instead of transforming them into a recreation zone cleared of all such traces. The idea of "recultivation as sculpture" did not gain attention until half a decade later, after Smithson's early accidental death. At that time, the King County Arts Commission in Seattle developed a programme to give artists an opportunity to present designs for deserted gravel pits, open-pit mines and landfills.

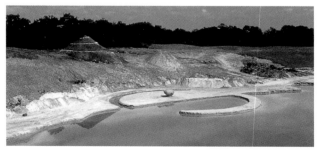

Broken Circle/Spiral Hill, 1971

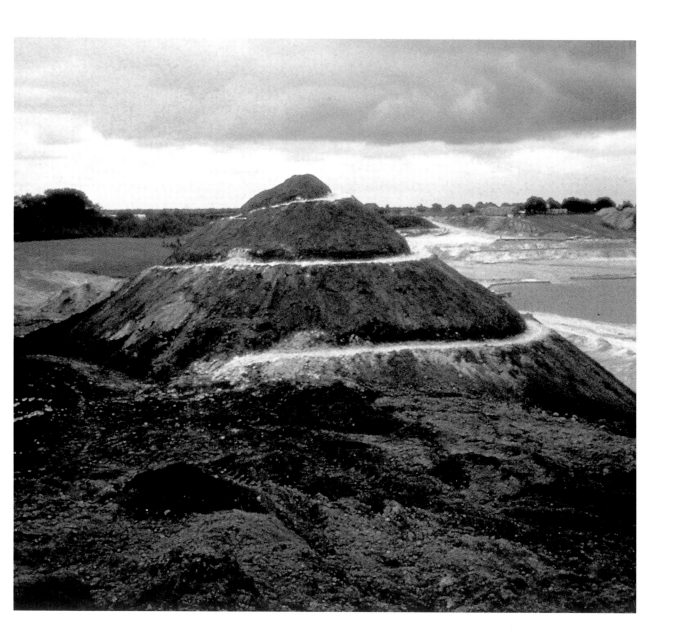

тime Landscape™

Intersection of Houston Street and LaGuardia Place, Greenwich Village, New York; vegetation, 14 x 61 m
Maintained by the Parks Department of New York City

b. 1946 in New York (NY), USA

In one of his lectures as early as 1968, Alan Sonfist called for another form of public memorial intended to honour and celebrate human society, the ecological system society is responsible for, and natural phenomena. With thoroughly ironic echoes of archaic rituals and ceremonies of nature worship, Sonfist was alluding to the proposal still fundamental to his work today: to make natural landscape spaces that have been overlaid and replaced by urban structures visible in certain locations once again.

In 1965, he began planning the project *Time Landscape*™ for a property approximately 14 x 61 metres in size in New York, on a section of LaGuardia Place between Houston and Bleecker Streets. He wanted to plant a miniature forest recreating the type of vegetation that would once have been in this location at the time of America's colonization. Sonfist researched the necessary data and had the site examined by a team of experts – a biologist, a botanist, a chemist, a geologist and an urban planner – in order to determine what natural conditions would have existed earlier, and the influence that present-day air-pollution and noise would have on the planned cultivation. He negotiated for years with municipal authorities, politicians, community members, and property-owner representatives to clarify the legal situation. Compared with this, the plan's actual execution in 1977 required much less time and expense. Sonfist also asked for help from the Greenwich Village local planning office, which represented the municipal government, and from the New York Horticultural Society and various banks.

Trees, bushes, grass and wildflowers have been growing again in the middle of busy downtown Manhattan since 1977. Sonfist by no means considers the restoration of such pre-colonial conditions as a romantic gesture, however, but as the symbol of a natural cycle. The history of a place includes the history of its natural surroundings, he explained. He wanted to show that it was possible, within an area of architectural monuments, to build landscape monuments. For Sonfist,

Time Landscape™ is therefore a pilot project for the reconstruction and documentation of local natural history.

A public monument should be oriented to a certain degree on natural history, ecology, geology and botany, the artist explained; each of these aspects is inherent to the sculptural form. Sonfist searches for nature's lost or hidden patterns and its structural organization, in order to transfer these to his memorials. Thus for his 1978 piece *Rock Monument*, a commission from the Albright Knox Gallery in Buffalo, he laid some large pieces of rock in front of the museum in the same arrangement he had found them in at another location. For *Pool of Virgin Earth* (1975), which he executed on a former chemical dumping ground at the Artpark near Lewiston, New York, he cleared surface contaminants from a circular area approximately 1.70 metres in diameter and then filled this area with fresh dirt. It caught plant seeds flying by, and in this way he hoped to recreate the region's previous vegetation. In the introduction of the anthology he published in 1983, *Art in the Land. A Critical Anthology of Environmental Art*, he also emphasised his ecological and artistic ambition to achieve 'cooperation with the environment' that he sees as necessary to avert its ultimate destruction.

> "within the city, public monuments should recapture and revitalize the history of the environment natural to that location."
>
> **Alan Sonfist**

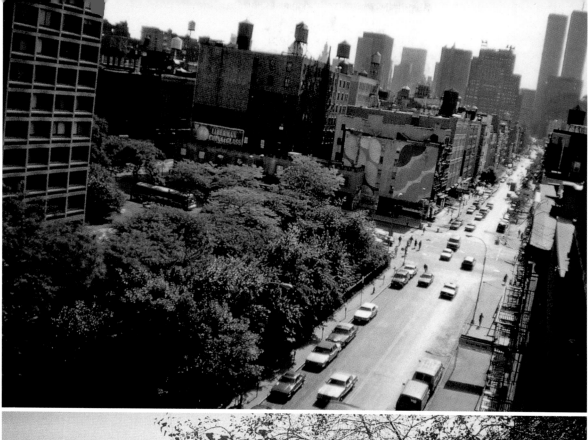

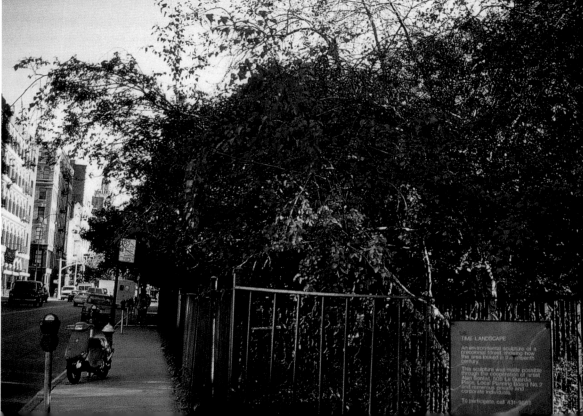

TIME-LANDSCAPE

An environmental sculpture of a
precolonial forest, showing how
the area looked in the sixteenth
century.

This sculpture was made possible
through the cooperation of artist
Alan Sonfist, NYC Boards
Parks, Local Planning Board No. 2
and numerous private and
corporate individuals.

To participate, call 431-9552

roden crater

Flagstaff, Arizona; volcano crater

b. 1943 in Los Angeles (CA), USA

The light projections that James Turrell has been developing since the mid-1960s to be shown inside museums have a unique haptic quality. Between 1968 and 1971 Turrell participated in the Los Angeles County Museum of Art's "Art and Technology Program", and there his close cooperation with the scientist Edward Wortz, who was researching the conditions of perception in space for NASA, would greatly influence his ideas. In his installations, one almost believes oneself capable of grasping the light; the projected light seems to solidify into a block or a cube-shaped space. The usual context of perceivable, tangible spatial depth dissolves, and the pieces create the unreal impression that one is in a boundless field of pure, coloured light.

The experience of boundlessness while flying, and his work on his *Skyspaces* in interior rooms, awakened Turrell's desire to have at his disposal broad spaces and almost unlimited dimensions. He therefore began, in the mid-1970s, to plan his largest and most expensive project involving light, which is not yet finished today.

70 kilometres north-west of the small town of Flagstaff in Arizona, a gravel road branches off the highway and leads between brushwood and bushes to the project site. The trapezoidal cinder cone of a long extinct, approximately half-million year old volcano, the Roden Crater, juts out of a lava field where the ground shimmers with dull copper tones and rust-reds. The volcanic cone rises about 300 metres above the Painted Desert that lies to the north, and is one of the so-called San Francisco Peaks, a sprawling volcanic region.

After buying the crater and 400 square kilometres of pasture-land around it in 1974, Turrell designed a system of rooms, connecting passageways, and lookout points for *Roden Crater*. Advised by scientists and the New York architectural office SOM, the artist designed the installation as a type of observatory, the primary purpose of which is the intense perception of light. The path starts at a small lodge halfway up the volcano's south slope. From there one climbs further upward to a concrete gate. Behind this lies a circular room, the *Sun and Moon Space*, with a tiny opening in the ceiling through which a beam of light enters. In this foyer begins the climb through the approximately 350-metre, semicircular *Alpha Tunnel* into the mountain, until you reach a bright room built on an elliptical ground plan, the *East Portal*, which has an oval panorama window built into its ceiling. After going through another section of tunnel, you arrive at the installation's centre, the *Eye of the Crater*.

Turrell explains, "The entrance from the tunnel into the crater space is made through an intermediate space which is similar to the earlier Skyspaces. The space at the top of this chamber creates a sense of flat closure of transparent skin. Steps proceed out of this chamber in such a way that the entrance does not occlude vision of the sky from the tunnel. Passing through the flat, transparent plane, the sense of closure recedes to a curved skin within the larger space of the sky."

The various tunnel passageways function according to the principle of a camera obscura. Sun, moon and planets should cast their light in specific positions in the volcano's interior in such a way that their image appears on projection surfaces at the end of the passageways. Turrell plans a highly subtle and spiritual performance of the stars, which is intended to lead the viewer to the boundary of what is barely visible.

"The crater space is formed to support and make malleable the sense of celestial vaulting."

James Turrell

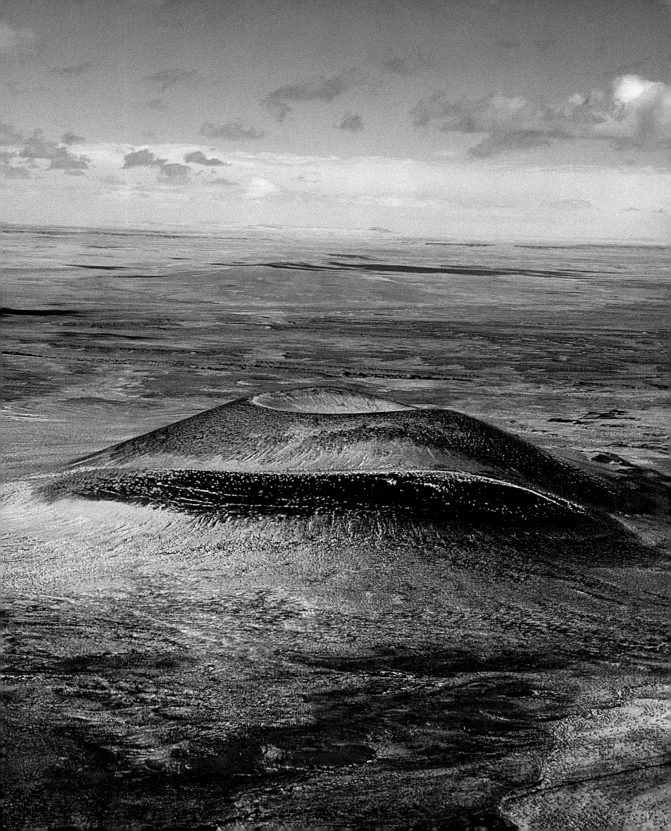

To stay informed about upcoming TASCHEN titles, please request our magazine at www.taschen.com/magazine or write to TASCHEN America, 6671 Sunset Boulevard, Suite 1508, USA–Los Angeles, CA 90028, contact-us@taschen.com, Fax: +1-323-463.4442. We will be happy to send you a free copy of our magazine which is filled with information about all of our books.

© 2007 TASCHEN GmbH
Hohenzollernring 53, D–50672 Köln
www.taschen.com

Editorial coordination: Sabine Bleßmann, Cologne
Design: Sense/Net, Andy Disl and Birgit Reber, Cologne
Production: Ute Wachendorf, Cologne
Translation: Sean Gallagher, Nanaimo, Canada

Printed in Germany
ISBN 13: 978-3-8228-5613-0

Photo credits:
The publishers would like to express their thanks to the archives, museums, private collections, galleries and photographers for their kind support in the production of this book and for making their pictures available. If not otherwise stated, reproductions were made from material from the archive of the publishers. In addition to the institutions and collections named in the picture descriptions, special mention is made of the following:
Courtesy Alice Aycock: pp. 21, 29
Courtesy Buffalo Rock State Park, Buffalo (IL): p. 57
Courtesy Cameron Books, Moffat, Scotland: p. 51
Courtesy Agnes Denes: pp. 40, 41 (all)
Courtesy Dia Art Foundation, New York (NY): pp. 37, 89 (photo: Gianfranco Gorgoni)
Courtesy Dwan Gallery Archives, New York (NY): p. 9
Courtesy Flick Collection: p. 87
Courtesy Hamish Fulton: p. 45, 47
Courtesy Barbara Gladstone, New York (NY): p. 43
Solomon R. Guggenheim Museum, New York (NY): p. 24
Courtesy Michael Heizer and Virginia Dwan: pp. 2 (photo: Michael Heizer), 14 (photo: Gianfranco Gorgoni)
Courtesy Nancy Holt: pp. 20, 58, 59, 60, 61
Courtesy Patricia Johanson: pp. 23, 66 (above and below), 67
Courtesy Kent Parks, City of Kent (WA): p. 31 (photo: Greg Minaver/John Hoge)

Courtesy Galerie Lelong, New York (NY)/Zürich: pp. 48, 49
Courtesy Richard Long: p. 70
Museum of Contemporary Art, Los Angeles (CA): p. 55 (photo: Gianfranco Gorgoni)
Courtesy Mario Mauroner Contemporary Art, Wien: p. 80
Courtesy Mary Miss: pp. 22 (right), 76, 77 (above and below)
Courtesy Robert Morris: p. 79
Courtesy Paul Rodgers/9W Gallery, New York (NY): pp. 92, 93 (above and below)
Courtesy Charles Ross: pp. 84 (above and below, photo above: Jill O'Bryan), 85 (photo: Charles Ross)
Courtesy Museet for Samtidskunst, Oslo: p. 19
Sammlung Marx, Nationalgalerie im Hamburger Bahnhof, Staatliche Museen zu Berlin – Preußischer Kulturbesitz, Berlin: p. 15 (right)
Sammlung Marzona, Kunstbibliothek, Staatliche Museen zu Berlin – Preußischer Kulturbesitz, Berlin: pp. 1, 7 (left and right), 8, 11 (left and right), 15 (left), 18 (left and right), 26 (below), 27 (photo: Adam Bartos), 36 (below), 39, 42 (below), 44 (below), 52, 74, 75 (photo: Giorgio Colombo), 88, 94, 95
Sammlung Marzona, Nationalgalerie, Staatliche Museen zu Berlin – Preußischer Kulturbesitz, Berlin: p. 83
Courtesy Frederieke Taylor Gallery, New York (NY): pp. 62, 63 (above, centre, below, photos: Peter Hutchinson), 65 (above, centre, below)
Courtesy James Turrell and Dia Art Foundation, New York (NY): p. 25
Courtesy Wolfgang Volz: pp. 4 (photo: Wolfgang Volz), 16 (photo: Thomas Cugini), 17 (photo: Wolfgang Volz), 33 (photo: Harry Shunk), 34 (photo: Dominique Lajoux), 35 (photo: Harry Shunk)

Reference illustrations:
p. 26: Carl Andre, *97 Steel Line for Professor Landois, Münster 1977*; 97 steel plates, 50 x 50 x 0.5 cm each, overall length: 47.50 m
p. 34: Christo and Jeanne-Claude, *Le rideau de fer*, 1962, Rue Visconti, Paris; barricade of 240 oil drums
p. 36: Walter De Maria, *Poster*, Galerie Heiner Friedrich, Munich, 1968; 60.9 x 57.9 cm, Sammlung Marzona, Kunstbibliothek, Staatliche Museen zu Berlin
p. 42: Jan Dibbets, *Postcard*, 1969; 10 x 15 cm, Sammlung Marzona, Kunstbibliothek, Staatliche Museen zu Berlin
p. 44: Hamish Fulton, *The Distance*, 1997; photograph and text
p. 60: Nancy Holt, *Buried Poem # 2*, 1971; portfolio with cards, drawings and texts
p. 66: Patricia Johanson, *Stephen Long*, 1968; red, yellow and blue acrylic paint on plywood, 61 cm x ca. 490 m x 1.5 cm
p. 72: Richard Long, *Stopping Place Stones*, 1974; photograph, pencil and coloured pencil on cardboard, 84 x 114 cm, Sammlung Marzona, Nationalgalerie, Staatliche Museen zu Berlin
p. 82: Dennis Oppenheim, *Annual Rings*, 1968; cuts in the ice at the border between the US and Canada, 38.10 x 50.80 m
p. 84: Charles Ross, *Prism Skylight*, Spectrum Building, Denver, Colorado, 1980; 15 prisms made of acrylic glass, 254 x 36 x 36 cm each
p. 88: Robert Smithson, *Poster*, Dwan Gallery, New York, 1970; 96.7 x 55.8 cm, Sammlung Marzona, Kunstbibliothek, Staatliche Museen zu Berlin
p. 90: Robert Smithson, Broken Circle/*Spiral Hill*, 1971, Emmen, Holland; earth, topsoil, white sand, *Broken Circle* Ø 43 m, *Spiral Hill* Ø 23 m

page 1
BRIAN ALDISS

Earthworks
1966, book cover
Private collection

page 2
MICHAEL HEIZER

Rift (Nine Nevada Depressions # 1)
1968, Massacre Dry Lake, Nevada;
excavation, ca. 16 m x 46 cm x 31 cm

page 4
CHRISTO AND JEANNE-CLAUDE

Surrounded Islands
1980–1983, Biscayne Bay, Miami, Florida;
11 islands, 585,000 m² polypropylene fabric